KAREN BYSTEDT

They Dared to Dream

HOLLYWOOD'S "A" LIST BEFORE THEY WERE STARS

INCLUDING PHOTOGRAPHY AND INTERVIEWS WITH BRAD PITT | ROBERT DOWNEY. JR |
JOHNNY DEPP | LAURENCE FISHBURNE | SANDRA BULLOCK | KEANU REEVES | COURTENEY COX |
PATRICK DEMPSEY | DJIMON HOUNSOU | JARED LETO | JOHN CUSACK AND MANY MORE

I would like to honor all the great actors in this book, for their incredible successes in both their Acting careers and Humanitarian endeavors. They had clear visions which they were able to manifest and serve as inspirational role models for us all.

I want to thank my husband Fredrik Bystedt and my mother Charlotte Ballard for inspiring me to continue working on this project and making it a publishing success.

Deep appreciation to Adrianne Casey and Steven Goff for keeping me focused and completing THEY DARED TO DREAM.

Natalie Kay and Veronica Sinclair, I am so grateful for all the work you did on editing the text. I couldn't have completed this book without you.

Thank you, Patrice Courtaban and Lisa Gutberlet for your support, expertise and guidance in negotiating the agreement.

Also, Thank You, Kevin Koffler for your invaluable contribution.

Lastly, I would like to thank publicist, Chris Harris for his creative input in designing the PR campaign.

Design by Jacqueline Domin, www.jaccadesign.com

ISBN: 978-0-9773399-0-7

Published by Channel Trade Books
(an imprint of Channel Photographics)
PO Box 150338, San Rafael, California, 94915
www.channelphotographics.com

Distributed SCD Distributions
15608 South New Century Drive Gardena, California 90248
P: 310-532-9400 F: 310-532-7001

Printed in China by Global PSD
www.globalpsd.com

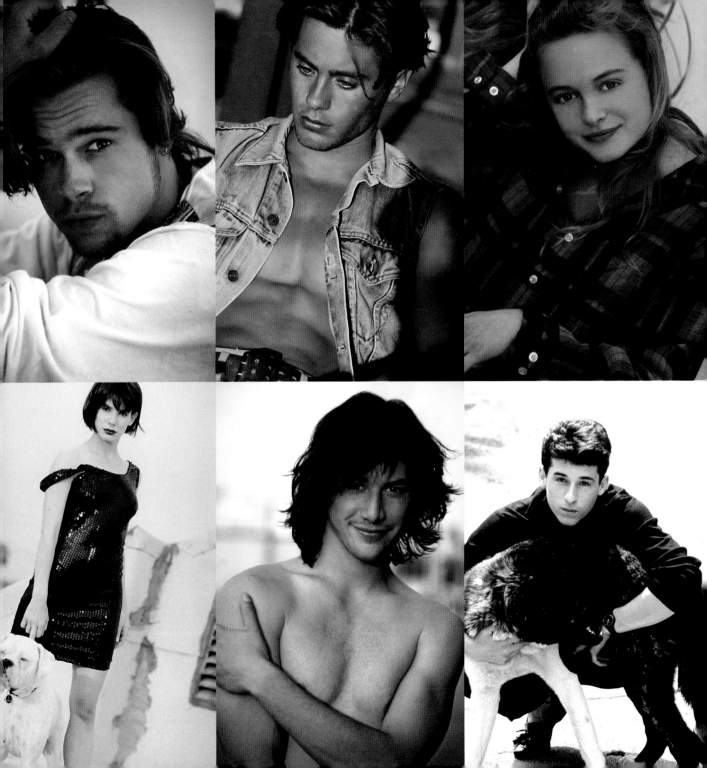

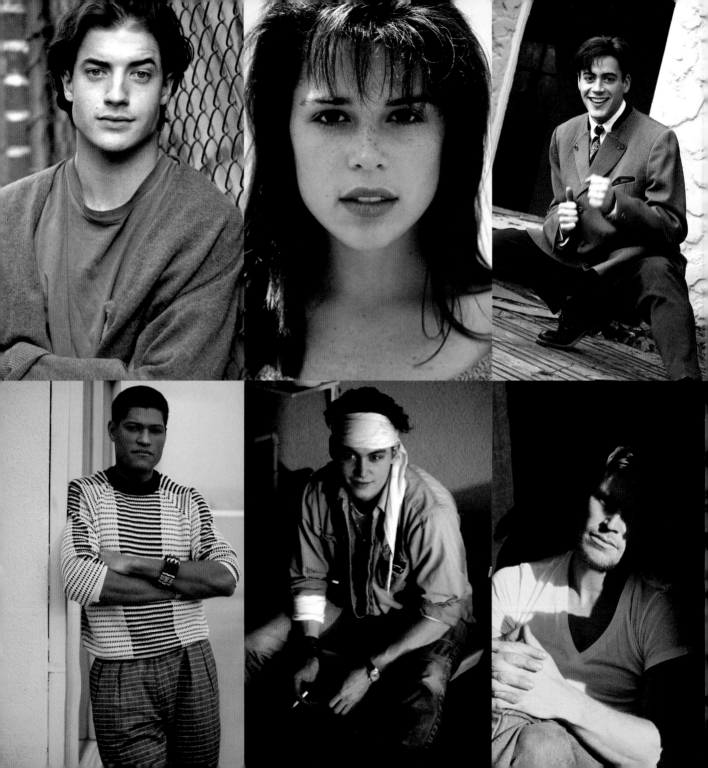

(TABLE OF CONTENTS)

BRAD PITT

I first heard about Brad Pitt in 1989 from his agent's assistant, Bill Danzinger who was really pushing for him, at the now defunct Triad Agency. At the time, I was compiling interviews and photographs of actors for the follow up to my book, THE NEW BREED: Actors Coming of Age. Bill raved to me about Brad, and was convinced that he would be a huge star. Another agent at Triad believed that Brad was "just a pretty face", but upon meeting him I was convinced otherwise.

I set up an interview and photo shoot at my studio apartment at the Franklin West Towers in Hollywood. Brad arrived fashionably disheveled, with his roommate, Canadian actor Bernie Colson, after completing eight loads of laundry. We went to my roof to do the photo shoot and afterwards I interviewed him over a beer in my apartment. At that time, Brad had just filmed a pilot which was not picked up. He booked his breakout role in THELMA & LOUISE shortly thereafter. I followed his career in awe, impressed by his decisions to play against his good looks by sometimes choosing edgy, sleazy characters. The first time I saw him on TV at the Oscars, I was reminded of when he talked to me about "pulling up on Oscar night and maybe that's pushing it, but you have to have dreams." Brad Pitt manifested his dreams with vision, hard work, and persistence and made them all come true without having any contacts in the business.

For a few years I would run into Brad at places like Trinity, a trendy club on Melrose, or at a private screening of KALIFORNIA with David Duchovny. Always down to earth and wonderful, success did not change him. It changed his dreams. Now, Brad has turned his attention to helping the greater world. Having recently traveled to South Africa and Zimbabwe, I have come to better understand Brad and Angelina Jolie's empathy for the African people. He has done amazing work to raise awareness for AIDS and poverty in Africa, and has dedicated himself to help rebuild New Orleans through his Make It Right Foundation. I have come to respect not only the actor but also the man along with the amazing woman he has chosen as his partner, Angelina Jolie.

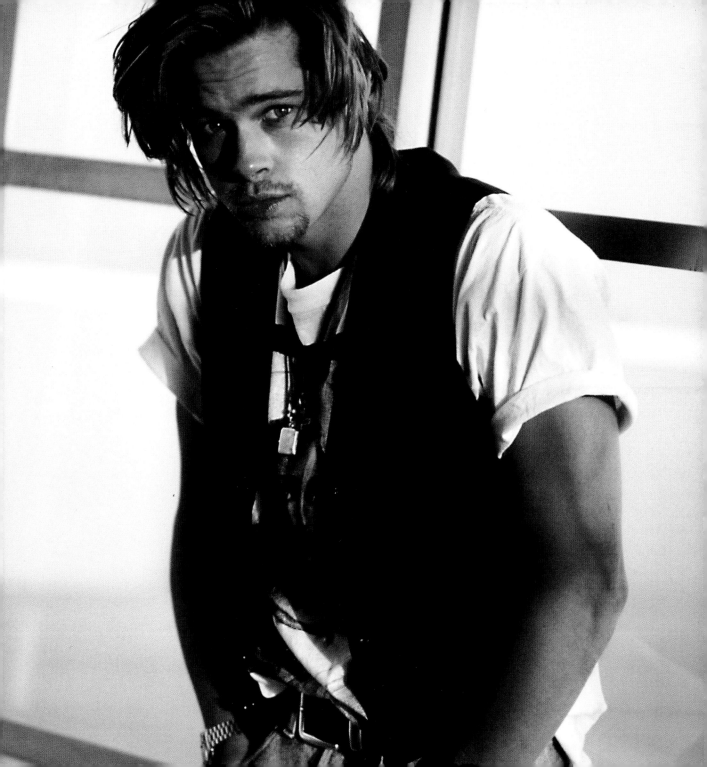

John Malkovich is king. He grooves me. I'm from Springfield, Missouri. I call it Swingfield because it's so exciting. That's sarcasm, in case you didn't catch that. The Springfield mall, home of the Kickapoo Chiefs. I went to Kickapoo high school. Yeah, I'm from Missouri, 2.3 kids, dogs in the yard, picket fences. The whole game. Apple pie intravenously. Where I grew up the only things that mattered were girls, cars, and baseball. That's all that mattered. And God. God always mattered. I was always in movie theaters. I'd go to apethons. They'd show five movies back to back, all the ape movies, PLANET OF THE APES. That was the best.

We don't have acting in MO. There is a local rep theater that puts on high school quality productions, if you're lucky. I'd always dream of being an actor, but I didn't tell anyone what I wanted to do. And for a long time I was frustrated because I never thought it could be a reality. You're going to be an accountant or an engineer or you're going to open up a lawn service. I used to be bummed because I figured I wasn't getting an opportunity because of where I grew up. When I first got to Los Angeles, I met this "Blond" California girl. I told her I was from Missouri and she said, "Is that a state?" So then I thought, "That's what kind of respect being from Missouri gets you." Now that I live in Hollywood and I see how messed up so many people are out here, I'm thankful I'm the guy from there. Everything works perfectly, you know. The big guy takes care of things, right? So, I'm out here at the right time.

At the end of 1986, I was a junior at the University of MO, majoring in advertising and graphic design, when I decided to pack up and give this thing a shot. I told my parents I was transferring to the Art Center in Pasadena, and would try acting on the side. They were totally supportive. My coming out here is the classic story, but it was such an adventure it was cool. I had $300 to my name. My car, a dented silver Datsun, which I named "Run Around Sue", was loaded up. I had my luggage high up to the back of my head and all the way to the top on the side and the passenger seat, where I couldn't see behind me, and just had a little room to shift. My philosophy was, all I need to see is forward. I'm heading west and that's all I need to see. I was such a dork. I just remember saying, "Yeah!" every time I would drive past a state line. I was so excited. And then I pulled into town and had my first meal at McDonald's and thought, "Now what do I do?"

> "I met these eight guys who had this crummy apartment and I crashed there for about half a year."

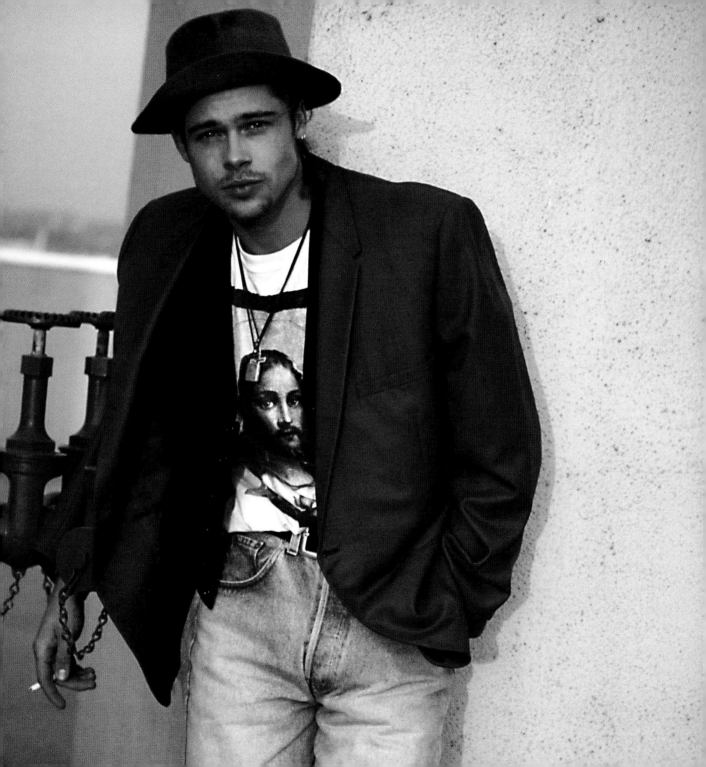

I met these eight guys who had this crummy apartment, and I crashed there for about half a year. I did all sorts of odd jobs, like dressing up as a chicken and being a delivery boy and driving strippers around. I did anything that was flexible, so I could figure out how to get into this frickin business. I started doing extra work the first week I was here. I mean, I didn't even know you had to have a head shot. I just dove in and things started clicking. I had to learn, I mean I wanted to. I didn't have a choice.

I got into a good acting class within the first three months, which is amazing. There are so many rip offs out here (in Hollywood). It makes me mad because I was one of those people. It pisses me off, cause they're messing with people's dreams and making money off of them. Anyway, I was driving strippers around on weekends to make extra money at nights. I'd take them to bachelor parties. I did that for about two months and then I couldn't hang with it. But then on the last night I drove, one of the new strippers told me about an acting class that her friend Charlie Sheen went to. I figured if it's good enough for Charlie, it's good enough for me.

I went to it. It was great. Then I got a scene partner. She had an audition with Triad Agency (which merged with the William Morris Agency in 1992). She asked me if I'd do a scene we prepared for class in front of all these agents. I said, "Yeah, I guess so, whatever." Boom. I got signed. It was a scene from ORDINARY PEOPLE. No, she didn't get signed. The fact was they took a gamble on me, because I'd never done anything and I wasn't in the union.

What's the key? The key is longevity.

But then that was half the battle. Here I was sitting in these audition rooms with these people who I'd watched on TV and films my whole life, and I was intimidated as hell. I freaked out and couldn't do anything for months. Nothing came out cause I was also so intimidated by the casting directors. I finally had to kick myself in the butt and say, "Let's go, cause here it is. Here's your dream, sitting right in your lap." And so I went.

Boom. It's been non-stop ever since. That was three years ago. Roy London was my acting Coach. He's a brilliant man. I still study with him. He taught me everything I know about the craft (acting). I've still got a ways to go. That's what's cool about acting, you're always learning. It's constant change. I love it.

My first job was a recurring role on DALLAS. I played this little kid whose hormones were running amuck, and who was always messing around with Priscilla Presley's daughter. They started to throw me in these Teen magazines. Man, it was a nightmare. That's such a huge trap. You burn out so hard. I was in there like a month. Then I said, "Yank me. Keep me away from them." Yeah, I think it can hurt you. What's the key? The key is longevity. So you've

got to stay low, do quality work, and cruise and do your own thing. Like doing a film and then going off and being a trucker. That's what my dad does. He owns a trucking company. After you see all this crap out here, it makes you want to go out on the road. Be a cowboy. Ride horses. Like Sam Shepard, my man. Sam Shepard is a demigod. He plays it the most cool. He stays low. He's got his horses. He's a brilliant writer. He's the man.

After half a season of DALLAS I moved on. Then I did a GROWING PAINS and a 21 JUMP STREET. After that I did a movie that I hope will never be released called CUTTING CLASS. I shot an independent film in Yugoslavia called DARK SIDE OF THE SUN, which was cool. I played a kid who has this skin disease where he can't be exposed to any kind of light. He decides to live three normal days in the light. He rips off his protective mask, which makes him look like an executioner, and he's just this innocent blond kid. We filmed in this thousand-year-old stone city, which was built by hand. Napoleon Bonaparte's castle lay up on the hill. We filmed this scene where I was in the water with a dolphin who hung out in the bay. I hopped in and the dolphin started swimming around me. And pretty soon it was like Sea World; only it was out in the ocean. I'd grab his dorfs, and he'd pull me down and pull me back up. It was amazing. I can still feel him.

The great roles right now are going to people like Sean Penn, because he's in the good position. So the key is to hop to that level, and then the brilliant writing will start coming in. It's all in the writing, you know. I just finished a pilot for a new series called THE KIDS ARE ALRIGHT" up in Canada. I don't know how it's going to go. I have a good feeling about it. But you know what, I'm not worried one bit, because if it doesn't go there'll be something else. Things have been working for me.

Spirituality. I just know that when you're one with God then credit's going to go where credit is due. The key is to rely on that and not worry about things. YOU DO NOT WORRY. Everyone worries out here. Worrying is the biggest waste of time, because things will work if you have faith. It's about faith. That's the word. That's the only word. If you start thinking you're too cool and become ego driven, you're gonna lose it. That's why it's good just to hang out with your buddies and your family and stay low. Stay low.

> Be a cowboy. Ride horses.
> Like Sam Shepard, my man.
> Sam Shepard is a demigod.

In this business there are times where we have free time. In between jobs I volunteer as a counselor for kids at a shelter downtown. Most of them are black and Hispanic. They've grown up in crack houses and are always in trouble. I mean how do these people even get a chance in life, starting out that way. But it's amazing to spend time with them. They're very cool. All they need is love. That's all. If you get a job that takes you away, it kind of hurts. They understand, but it's hard getting in tight with them, where they really trust you, if you're leaving. One thing I've come to realize that if you are in the public eye, which I haven't even touched on what it will be yet, you have this responsibility to give back. People are watching you. I know I've been disappointed by people. I'm not preaching. For me it's personal. Doing this makes me feel better.

My family is so great. My mom is the sweetest person in the world. If I didn't have them to call home to twice a week, I don't know if I'd still be here. They are so proud of me. They wallpaper the house with anything that comes out on me. It's cool. I'm lucky to have that support. In terms of my personal life, I'm just a bum right now. Barney (Brad's roommate at the time, actor, Bernie Colson) borrows my underwear and it bums me out. I have no grungies left. No boxers, you know. I'm doing the old reversal boxer routine. In fact, I just got back from doing laundry. I did eight loads at the Laundromat. God forbid if we run out of toilet paper. It will be a week until I finally get off my lazy butt and go get it.

We don't even own a TV anymore. It broke down three months ago. The next day we were going to buy a new one, but we didn't. I'm reading so much more now. It's in the writing. Good writing moves you and it makes you think. People like David Rave and David Mamet and Langford Wilson.

What were my dreams? I haven't hit them yet. I haven't hit them yet. I'm getting there. As a kid, I dreamed of opportunity because I knew things could happen. I'll be honest. When I was young, sitting in my little back yard, playing with my puppy or whatever, eating Twinkies and drinking Kool-Aid, I'd dream of fame. It sounds so cheesy, but there were flicks that moved me, that shaped me as a kid. I remember my dad taking me to see BUTCH CASSIDY AND THE SUNDANCE KID, and I remember crying at the end, at that scene when they get blown away and the camera freezes on them. Flicks like, ORDINARY PEOPLE and ONE FLEW OVER THE CUCKOO'S NEST, they move you and shape you, and I want to be a part of that. But also sitting in my yard, in my sand box, I'd dream of fame and fortune. The lifestyles of the rich and famous are very attractive. I'm being perfectly honest, that was part of the attraction for me to be the number one guy. Then you get out here and you just want to be good. You start to get into it. I didn't study acting at home. I got out here and I had so much to learn. ★ BRAD PITT, MAY 1989

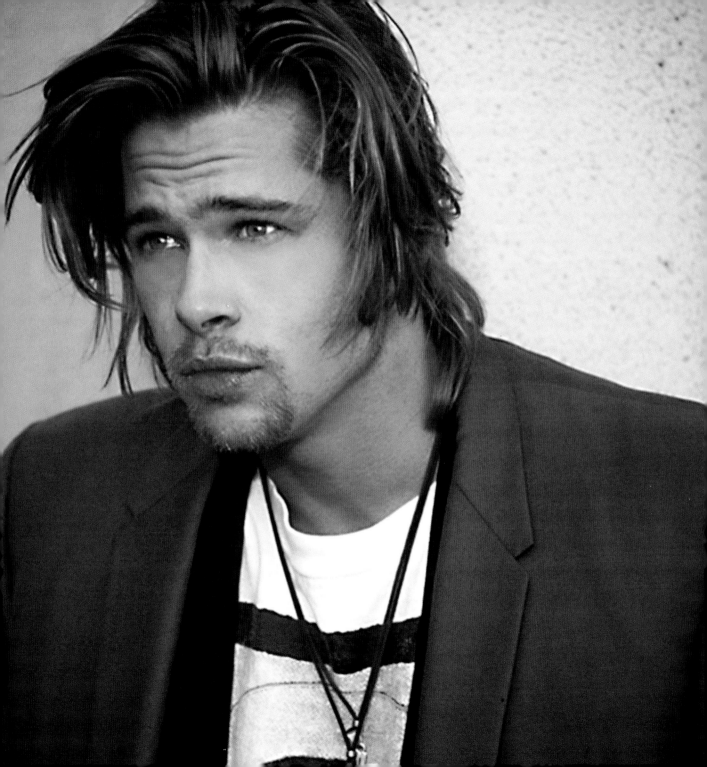

ROBERT DOWNEY JR.

I first met Robert Downey Jr. at a reggae club in Los Angeles. Struck by his intelligent humor and charisma, I accepted his offer to buy me a drink. At the time, Robert was a rising star in Hollywood with films like THE PICK UP ARTIST and LESS THAN ZERO under his belt. One evening, Robert and I ran around Hollywood, and ended up drinking at the Sunset Marquis. Another time, he showed me his collection of beautiful jewelry bought from his manager, Loree Rodkin, who would eventually leave the business to become one of the most popular jewelry designers for the rich and famous.

By the time I photographed Robert, he had bought a house on Queens Road above Sunset Boulevard, and acquired a taste for designer suits, such as Armani and Versace. As I got to know him, I realized that beneath Robert Downey Jr.'s bright, amusing, and intelligent exterior laid a tortured yet luminous, spiritual old soul; one that had suffered through a difficult childhood.

Undeniably talented and flawed, Downey went on to win an Academy Award nomination for his performance in CHAPLIN and lose a well-publicized battle with addiction. After a year incarcerated in a Federal facility, Robert pulled his act together. He resumed his brilliant acting career, and sorted out his private and emotional life.

His break into super stardom finally came with the role of Tony Stark in IRON MAN. Playing a billionaire genius playboy, who creates an iron suit to battle evil, Robert's relation to the character was crystal clear. Both had turned their darkest moment into their greatest triumph. In May 2008, IRON MAN debuted with approximately $100 million at the box office, the second largest opening of any non-sequel film after SPIDERMAN. Robert's witty charm is back, and he has redefined his career as an assured movie star.

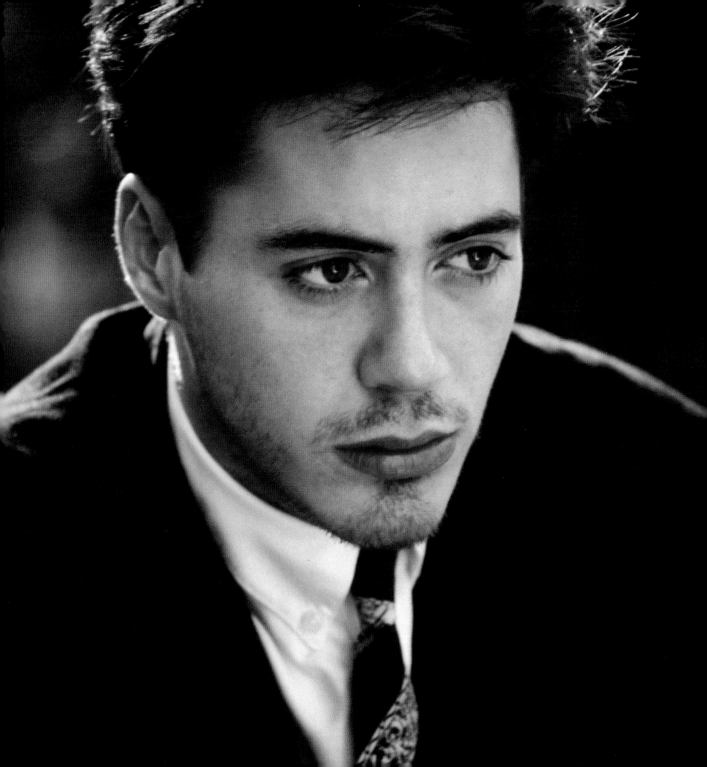

(ROBERT DOWNEY JR.)

I moved out on my own six years ago. I lived on Ninth Avenue and 52nd Street in New York City. There were no windows that you could see out of. I just remember it being a really depressing, claustrophobic place that I actually had a lot of fun in. I was a busboy at Central Falls Restaurant in Central Park. I don't think it was tough monetarily. As a matter of fact, it was the best thing that ever happened to me when my dad said, "I've carried you for too long. You're 18. Don't call me up to even ask me for a dollar. I don't care if you call me to tell me you are hungry." I remember that was a point of transition where I decided, "Fuck, I really have to grow up now."

My family lived everywhere: New York, London, California, Woodstock and Connecticut. One day I'm going to ask my dad what year we were where, 'cause I'm just spacing. It seems like so much of my past, I really don't remember.

There was always a lot of pot and coke around.

Maybe it's because I have these screen memories of the times that were very emotionally difficult. I grew up in a family where everyone was doing drugs and trying to be creative. There was always a lot of pot and coke around. It wasn't like my dad was such a drug addict. Drugs became an excuse for him to do his writing, or his writing became an excuse to do drugs. When my dad and I would do drugs together, it was like him trying to express his love for me in the only way he knew how. We first did drugs together when I was very young. To me, it always seemed like a staple in life. It was cool, but I never felt like any other fucking kid at my school. I moved around a lot. Whenever I'd tell my dad I met someone or made a good friend, he'd say, "Pack your bags. We're leaving."

When I was 14, my mom and dad's marriage was over. I stayed with my mom because she needed me. They were married and had been creative partners for 15 years, and the separation left her shell-shocked. My sister went with my dad, for reasons only she knows. She was the one they had sent to private school, and thought was going to do great things. I was this weird pothead kid, who got off blowing away frogs with my BB gun. I went with my mom because she needed me. We moved to 19 E. 48th Street between Madison and 5th. It was a five floor walk-up in this depressing fucking place with no windows...well, there were windows, but there were bars in them and there was always this grainy, gray light coming through them. It always seemed like it was 6:00 PM. I can't relate to real poverty, but we were cooking on a burner instead of an oven and we were trying to create a sense of family or happiness in the skankiest of surroundings. I didn't spend much time there. I was out with the boys, hanging out in

Washington Square, going to the ROCKY HORROR PICTURE SHOW, doing whippets and intermittently, stopping back in the house to steal most of Mom's cash. I think just the fact that I was there for her was kind of enough, in a way.

I'd always known that I was going to act. From the third grade when I played the evil lord trying to take over the princess's house to when I did OKLAHOMA in high school, but it was while I was doing this play FRATENITY, across from the Public Theater, that I realized that acting was something that was really good for me and that it was something I needed to do.

Substance abuse is just a really easy way to give you something to do every day.

Most of the things in my life were pursued out of necessity, not out of desire. I had this extreme paranoia that led me to be good. I was so afraid of not having my shit together. I'd get to the theater an hour and a half before every show, stretch out on this mat, and run over actions and transitions in my head. This paranoia gave me discipline. The others guys would come in and say, "Downey's gone to Nirvana again." I'd also help them strike sets, and loved the fact that I was getting $50 a week.

At that time in my life, I was also just getting into spiritual stuff; like the human energy systems, auras, and projections of consciousness. I felt like it wasn't even me going to get all of these books. It was my higher self saying, "Fuck, this kid's in trouble; we'd better surround him with a lot of good thoughts." I had gone through a period of being self-destructive because it's so much easier to spend every night going out, getting drunk with the boys, and making a thousand phone calls a day in pursuit of drugs than to stop and say, "OK, what am I going to do tomorrow?"

Substance abuse is just a really easy way to give you something to do every day. It's something you know you always get the same result from. Rather than trying something different, like changing your life then you don't know what the results are going to be then, success or failure. I've never failed to get high from smoking a joint; I've never failed to get depressed from doing coke. Even though there are usually negative outcomes, at least you know it's going to be from the same negative every fucking time and it's so comfortable. I've been a dead horse with sobriety for three years. Quitting, slipping, quitting again and it's enough. I kept it up until fairly recently but now its time to move on. LESS THAN ZERO was sort of a catharsis for me. Except the difference between Julian and me is that Julian had a

death wish. He just wanted to die. Maybe I've ridden that fucking line desperately, without a net, but if I had gotten into basing, I'd be dead now. I know my limitations. I know I'm excessive, and I know I'm not going to kill myself. While I was doing FRATERNITY, I was sitting in my apartment; feeling potentially suicidal and the phone rang. It was the agent my dad had hooked me up with. He told me he had gotten me in to read for FIRSTBORN. I went in to read for this obnoxious English director. He cast me, and I thought, "All right, maybe something is going to happen now." My initial goals were external. I wanted to make a million dollars, have my name above titles, have everyone know who I am and all of my friends saying, "I wish I was him." I didn't think I'd be any happier, but, at least, I'd have the guise of success. Now my goals are more internal. They still have to do with the business I'm in but they are to make myself happy and whole. Acting really helps. It gives me a focus and lets me express stuff that, maybe, I can relay to other people. I don't really think we live in the "real" world. I keep having flashes of what I think reality is, which is the simultaneous nature of time and energy beyond all matter. We're all from that reservoir. That's why when I hear people say, "Downey has such screen presence," I know all they're seeing is the reality of the spirit behind the matter. I feel that what's really home is not my body, my car, or anything I can really touch. It's the things with the inner senses. I think that's where everyone and I have the most work to do. That's why I like sleeping so much. I really know where I am when I'm sleeping, even if I don't remember it when I wake up. I'm home when I'm sleeping. Lately, I think the most important thing for me, as an actor, is to keep working. I want to keep learning. I'm in a position to start saying "No" to projects. Most of the scripts that are submitted now make me so fucking angry. Where have we come if in the 1980's and hopefully the beginning of the Golden Age, all the scripts are about guns and dicks? It's sort of entertainment, but nothing really happens. It's so geared towards violence, self-indulgence and mindless comedy, without any intellectual backup. It's easy for me to keep picking scripts that are very easy for me to do. So now, I look for roles that I wouldn't think I could play right off the bat. I'm looking for something where I know I'm going to have to trust myself and expand. It really comes down to, "Is this script going to teach me something about myself?"

I want to do films about spirituality and what's really going on in this undercurrent of majestic reality everyone is trying to suffocate and not confront. I want to do films where people discover themselves, in ways that would be great to shoot. I'm trying to get the rights to this book titled, "Way of the Peaceful Warrior" about a guy whom while going to school in Berkeley encounters a warrior from another plane of reality. He is a world-class gymnast and has everything, yet he has nothing. The warrior seeks him out because he knows this guy is meant to write a book. I want

to do films that will move people without being preachy. That will offer one man's means to an end. That will give him peace. Hollywood really isn't ready yet for the kind of films I want to do.

My biggest sacrifice for success has been losing touch with the day-to-day reality of a modest existence.

Would I do a nude scene? Sure. What it would come down to is me saying, "I hope I don't get a hard-on." It would be distracting to the crew, and I'd be embarrassed because, shit, maybe it's not as big as I want it to be. You can expose yourself in a lot more ways than taking your clothes off.

Do I consider the affect a film will have on my audience? I do more lately. I'm not worrying about money. So my struggle is more about accomplishing my goals. I was in Georgia and this lady came up to me shaking and said, "I saw you in LESS THAN ZERO." I felt like saying, "You're every bit as special as I am," but I was in a pissed-off mood so I said my usual thanks and started to walk away. Then she said, "Two of my friends went into rehab after seeing you in that movie." I got chills up and down my spine and thought, "Fuck, now I know why I do what I do."

My image is of a guy who never thinks about anything, has a good sense of humor and does crazy things without thinking of the repercussions. There's a more serious side to me that sits at home, reads and is quiet. Everyone wants to feel that they're in touch with someone and it's a great conversation piece, but me, the real me, is something only a few people know.

Mediocrity is my biggest fear. I'm not afraid of total failure, because I don't think that will happen. I'm not afraid of success, because that beats the hell out of failure. It's being in the middle that scares me. My biggest sacrifice for success has been losing touch with the day-to-day reality of a modest existence. Los Angeles isn't reality and making a movie in Los Angeles is a double-entendre of non-reality. I never get to spend time alone anymore, and that has to change. I need time to recharge my batteries.

I love life and I would never give up. I put myself here. I'm certainly not going to cop out and I really feel blessed that there's some Gabriel, or whatever entity, that is watching over me. ★ ROBERT DOWNEY JR., 1988

COURTENEY COX

I first heard about Courteney Cox while living in New York City. My Norwegian girlfriend Katrina was living in a loft in Little Italy with her Liverpudlian roommate, Paul. During a trip to Los Angeles, Paul had fallen madly in love with a beautiful young actress named Courteney Cox. Her claim to fame, at the time, was a music video she had done for Bruce Springsteen where she played the lucky fan who he pulled onto the stage.

A few months later I visited Paul at the downtown clothing mart in Los Angeles and met Courteney. She was extremely beautiful and self-assured, one of those women who appears to have everything in their lives under control. Since I have always believed in following life's leads, I asked Courteney if I could interview her for my book THE NEW BREED, and she agreed. We met at her cozy, eclectic house in the hills above Hollywood, where I was taken by her amazing taste for decorating.

Later, Courteney appeared in her breakout role opposite Jim Carey in ACE VENTURA: PET DETECTIVE before starring in one of television's mega-hit sitcoms, FRIENDS. Now part of a Hollywood power couple with husband David Arquette, Courteney produces and stars in the sexy tabloid drama DIRT.

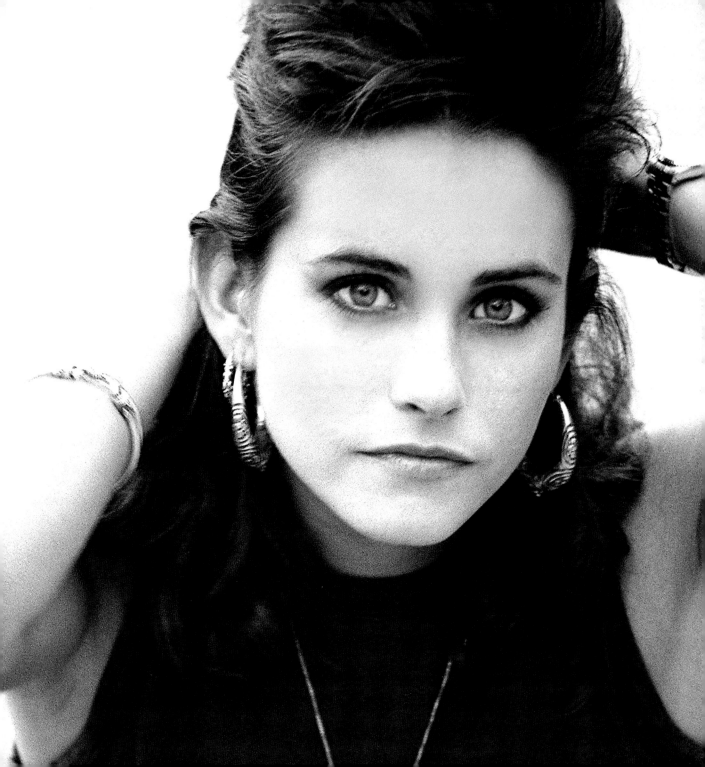

in her words

(COURTENEY COX)

My parents got divorced when I was 10. I was at camp. Even though I knew they were separated, the divorce really upset me. When I got home from camp, my brother and I tried to set our parents up on dinner dates. He'd take my father out and I'd take my mother, and we'd meet at Wendy's. We tried everything, but nothing worked. My dad moved from where we lived in Birmingham, Alabama to Florida, and my mom got only $400 from him in child support. We didn't have a lot of money to buy clothes or do what we wanted to do. I got very resentful towards my mother, and as a result very independent.

I got my first job after school when I was 13. I wanted to buy clothes and save money for a car. I called names out of the phone book to raise money for the Retardation Foundation. I was very ambitious. All through high school, I took a full load of classes and worked 40 hours a week.

My mother remarried and my stepfather's nephew was Miles Copeland, who managed The Police and owned IRS Records. Whenever the band would come to Birmingham, Miles would fly down for the show and stay at our house. He would always say to me, "Courteney, you've got to get out of here, you're too ambitious to stay in Birmingham. You're going to have to leave at some point, so why don't you come to New York?" I'd laugh at him and say it was a nice dream, but get real.

During my senior year in high school, The Police played a show in a big arena in Birmingham. Miles invited me to a Police concert in New York two weeks later, and said he would take me to interview at the Ford modeling agency. I was very excited, but I wondered how he was going to get me in. I'm only 5'5", and it wasn't like they were excited to meet girls from Alabama who had never done anything

> I got my first job after school when I was 13. I wanted to buy clothes and save money for a car.

aside from ads for a local department store. He had gotten the interview by bribing an agent with two free Police tickets for that night's sold out show. When they met me they thought I was too short, but decided to send me out on two interviews anyway. I lucked out. One of the interviews was for Young Miss Magazine. I booked the job that day. When I graduated from high school a few weeks later, I moved to New York.

When I first got there, I slept on different peoples' floors. When I finally saved enough money to afford an apartment,

I moved to the Upper West Side of Manhattan, where I shared a one-bedroom apartment. The rent is so expensive in New York. All the money I made went to pay for rent. My best friend lived downstairs. I used to call her and say, "I don't have money but do you want to have dinner?" Then I'd bring down a can of tomato soup, a loaf of bread, and a tub of whipped butter. I'd have six slices of bread and butter and a bowl of tomato soup. Once in a while, I'd add a can of tuna. That's all I ate for nine months. But I was ambitious and I wanted to succeed.

> ## I'd have six slices of bread and butter and a bowl of tomato soup. Once in a while, I'd add a can of tuna.

I hated modeling. I wasn't tall or beautiful enough to become a real model. Once I got my first commercial, I quit print. I started taking acting lessons and speech lessons to lose my southern accent. My real break came when I got the Bruce Springsteen "Dancing in the Dark" video. Brian DePalma cast me over a couple hundred other girls. He wanted someone who could look surprised when Bruce pulled her out of the audience, take after take, and that was me.

After I did that, I was flown out to Los Angeles to screen test for a pilot that I didn't get. But I did end up getting the series MISFITS OF SCIENCE, because, by chance, someone had walked me over to that set after my screen test. After doing the film MASTERS OF THE UNIVERSE, some guest TV roles and a TV movie for NBC, I got FAMILY TIES. On FAMILY TIES, I played Alex's (Michael J. Fox) girlfriend, Laura. She seems like an easy role to play, but she and I are completely opposite. Sometimes I'm amazed by some of the words that come out of her mouth. It's strange. My friends see me on the show and say, "You would never have done that." I explain that it's a role; I'm not playing Courteney Cox. FAMILY TIES is going to last one more season, and I'm now looking for dramatic roles. A lot of people put down television, but I'm working in front of 300 people every week and that's been an incredible learning experience for me.

There are so many levels of success and right now I'm at the bottom. If you're talking about real SUCCESS, my goal, right now, is to just get through each day and to try to keep my eyes open, and learn as much as I can. I'm by no means where I want to be yet as an actress. I still have a lot that I want to accomplish. ★ COURTENEY COX, 1987

DJIMON HOUNSOU

In 1992, I was photographing male models for a book. It was then that I met Djimon Hounsou at his modeling agency in Los Angeles. For our shoot, he picked me up in his Jeep with his Rottweiler in the back. While shooting at Topanga Beach during sunset, I was taken by Djimon's warmth and humor. Later, as I interviewed him in my living room, I couldn't help but think that his life sounded like a Hollywood movie.

Born in Africa, Djimon was the youngest of five children. While growing up in the small village of Cotonou, Benin, Djimon developed a love for movies. Every week, he would frequent the local cinemas to watch American Westerns. At 13, Djimon was sent to Lyons, France, to attend boarding school and live with his oldest brother Edmond. After Djimon dropped out of school, he was disowned and financially cut off from his family. Fleeing to Paris, Djimon became homeless. He slept under bridges, begged for food in the Metro and bathed in public fountains.

It was then that his luck changed overnight. French fashion designer Thierry Mugler discovered Djimon while searching for an unknown face for his new line. According to Djimon, "I went from being dirty and sleeping on the streets, to having a bubble bath at the Plaza Athenee, and ordering champagne." After working for Thierry Mugler, Djimon's modeling career took off. He traveled the world before eventually landing in Los Angeles, drawn to the town by his passion to become an actor.

When I photographed Djimon, he had already received his first break by being cast in Janet Jackson's video for "Love Will Never Do Without You". The video drew attention to his presence and physique and landed him several more videos; including Madonna and Steve Winwood, and a minor role as a nightclub bouncer in BEVERLY HILLS 90210. His big break came in 1996 when Steven Spielberg auditioned him for the role of Joseph Cinque the leader of the slave revolt in AMISTAD. Djimon landed the role, and earned a Golden Globe nomination for his performance. Since then, Djimon's career continues to flourish. He has worked alongside Russell Crowe, Leonardo DiCaprio and Heath Ledger, and received Academy Award nominations for his performances in BLOOD DIAMOND and IN AMERICA.

Following our shoot, I would run into Djimon at Rocket Video, a great independent video store catering to foreign and rare films. While his taste in films might have changed over the years, his passion for them is stronger than ever. After each encounter I would walk away energized by how far Djimon has come in pursuit of his dream. Djimon continues to live his Hollywood dream and now shares it with entrepreneur Kimora Lee Simmons.

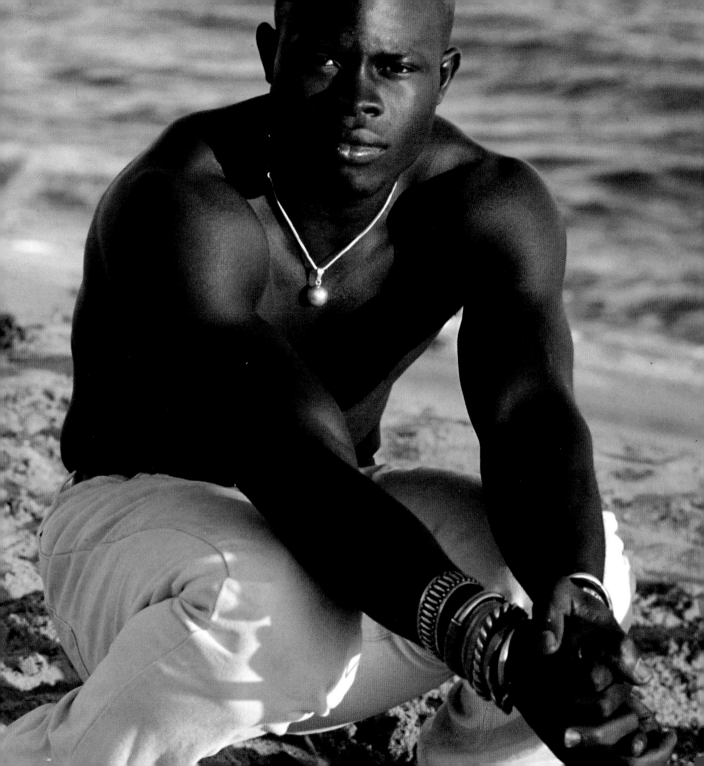

JOHNNY DEPP

I first saw Johnny Depp in a sexy photo spread in 1987. He wore a fitted t-shirt with a cigarette pack tucked into the fold. Leaning against a shiny motorcycle, his hair was slicked back, James Dean style, and his arms adorned with cool tattoos. Immediately taken by his beautiful bone structure, I inquired about him and discovered that he was starring in the popular TV series 21 JUMP STREET. At the time, I was looking for actors for my book THE NEW BREED: ACTORS COMING OF AGE. I sent an inquiry through his agent at ICM, and Johnny agreed to participate.

I met Johnny at his modest, one-bedroom apartment in an Art Deco building on Whitley Avenue. In person, he was much more disheveled than the cool photos I had seen. He was a sweet, if not slightly tortured soul and absolutely perfect for my book. In my experience, all great artists are messed up to some degree. After our initial shoot, I would run into Johnny, often accompanied by Nicholas Cage at screenings or Canters after a late night out.

Johnny went on to do many quirky, artistic films, such as EDWARD SCISSORHANDS and SWEENEY TODD, for which he earned an Academy Award nomination. His brilliant Keith Richard - fueled portrayal of Captain Jack Sparrow in THE PIRATES OF THE CARIBBEAN trilogy finally propelled him to international superstardom. Johnny Depp manifested his goals by portraying unique and interesting characters instead of the conventional leading man roles his agents pushed him toward.

In 1993, I photographed Johnny again for a Japanese Edwin Jeans campaign. We laughed and spoke German to each other as a limo shuttled us between a friend's Venice loft and Santa Monica's 14th Street cemetery. On a personal note, I am so happy that Johnny met the beautiful French singer/actress Vanessa Paradis, and had two beautiful children with her. For now his personal life is as centered and joyful as his creative life.

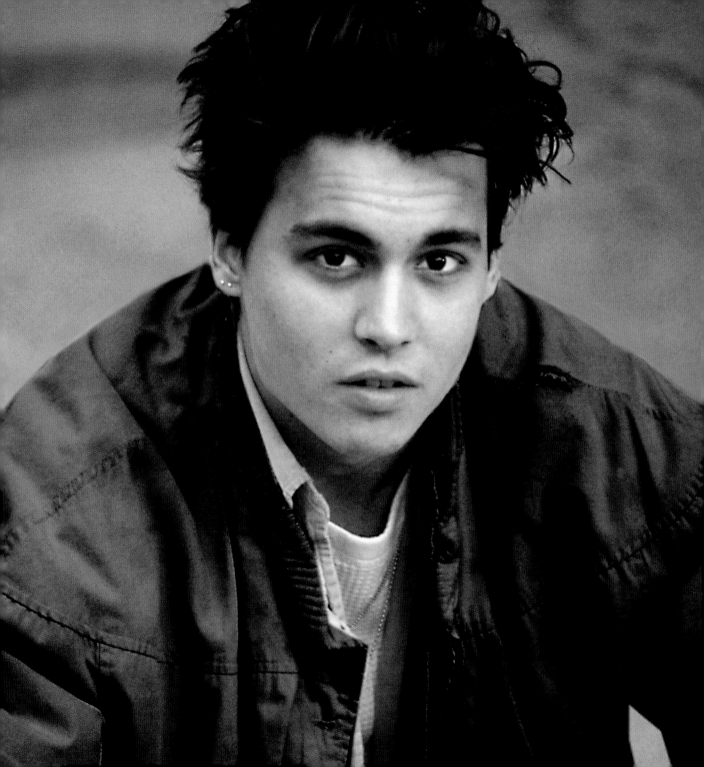

in his words

(JOHNNY DEPP)

I grew up in many different houses. One in Miramar, Florida, that sticks out in particular was on the corner of a busy street at 68th Ave and Court. It was a three-bedroom house, built in the sixties. I remember the constant smell of my mom's cooking: soup, beans and ham. My brother and sister were always fighting. I had a poodle, and shared a bedroom with my brother who is ten years older than me. He listened to a lot of Van Morrison and Bob Dylan.

I was very mischievous as a boy. I loved tape-recording people when they didn't know. One time, a friend and I dug a really deep tunnel in my back yard. We covered it with boards and leaves. I was attempting to dig a tunnel to my room. I liked to push it and see how far I could go.

We moved constantly. My mom just liked to move for some reason. By the time I was fifteen, we had lived in about twenty houses. It was hard. Depending on how far we'd move, you'd have to make new friends. Fortunately, I didn't have to change schools often. But we never stayed in one neighborhood for long. At the drop of a hat, we'd go. My mom was a waitress. She's been a waitress since she was fourteen. My father was a director of Public Works in Mirimar. They divorced when I was about sixteen.

> When I do a role, I bring as much of myself into it as I can, but I also try and take on characteristics of the role.

To this day, I hate it when I have to move from location to location. I get very angry, as a result of having had to move so much as a kid. I live in Hollywood now but I'm in Vancouver shooting 21 JUMP STREET about nine months of the year.

If you knew me during high school I think you'd describe me as "the kid with long hair who was always playing guitar." I wasn't big on participating in school activities. I used to bring my guitar to school and I'd skip regular classes to sneak into guitar class. The teacher would give me a practice room to play in. That's pretty much what I spent high school doing.

You know, I never made a decision to become an actor, at least not in the beginning. I got into it off the cuff. I moved from Florida to Los Angeles with a band I was playing with called "The Kids". A friend of mine introduced me to Nicholas Cage and we started hanging out. Nick thought that I should try acting and see what would happen. At the time, I wasn't making much money. I played a few clubs with the band here and there, but I still had a lot of time,

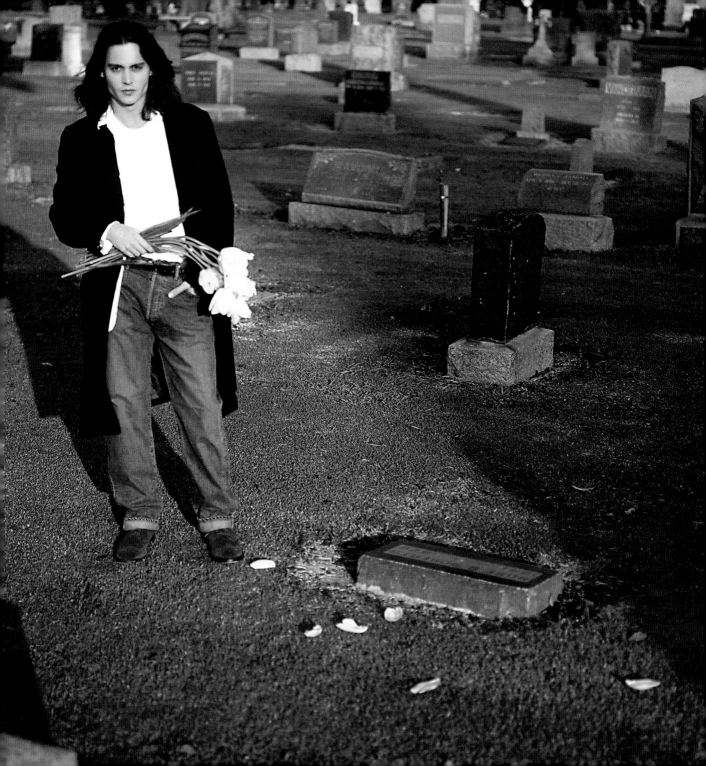

so I decided to give it a shot. Nick set up a meeting for me with his agent and she sent me to read for a movie. They gave me a script to study. Two days later, I read for it and they gave me the role. That was NIGHTMARE ON ELM STREET.

Doing NIGHTMARE ON ELM STREET was a trial by fire sort of thing. I'd never acted before. I'd never done school plays; nothing. The fact that it was totally new to me was a tremendous challenge, I'd never done anything like this before; Hitting marks and saying lines and thinking about why my character was doing what he was. It was totally the opposite of being in a rock & roll band where you were four people, all working together to write great songs or to get a record deal. In acting, I found it was just me and it all depended on me and my own choices. The band wasn't going well, so I changed my energy towards acting.

After ELM STREET, I did a terrible sexploitation film called PRIVATE RESORT. I did it because I needed the money badly and at that point, I couldn't afford to be choosey. I figured at least I was earning my living by acting, and that beat working at Burger King or McDonalds. The film was a piece of shit but I knew it would give me the opportunity to experiment and see how far I could go before pissing off the director and producer. For them it was a teenage exploitation film; for me it was an opportunity to learn and to get paid for learning.

The major turning point in my career was PLATOON. Even though a lot of what I did was cut out, it was still one of the best experiences of my life. When you are taken out of your everyday life of trying to get a job and this and that, and you're put into a situation where you're living with 30 other guys in the jungle of a country you know nothing about and you're living on rations, you become incredibly tight · like brothers. We watched each other's backs and overall it was a very strange experience.

When I got back I was very depressed. After being in the jungle for two and a half months with those guys and working on a project like that, coming back to life in L.A. was very difficult. On a smaller scale, I think it was a lot like what soldiers felt like coming back from Vietnam. One day they we're in the jungle fighting with our buddies, trying to save their ass and two days later we're walking down La Cienega Boulevard looking for a hot dog.

I drank a lot. I played with a rock and roll band again for a while. I drank more, and I got more depressed. I missed my buddies and everyone had gone their own way. Finally, I started to audition again and it was about six months later that I got 21 JUMP STREET.

Television is a grind, it does not allow for experimentation. You don't have enough time to do much more than learn your lines and get to the set. In features you have loads of time to do the work, and the work is the most important

thing of all.

But if I have to do television, I'm glad it's on 21 JUMP STREET, because at least the show possesses a sense of honesty and confronts serious issues like suicide, drugs and child abuse. At least there's potential there to help somebody. Whatever I'm doing must, in one way or another, possess a sense of truth. I can't force something out that's not honest to me. In any character I play, be it a rapist or a priest, there must be some element about that person inside of me that can come out. Otherwise it won't work, it's just a lie.

The best part of doing television is that it has increased my visibility in the business. The worst part is that I have to spend nine months out of the year in a hotel room in Vancouver, British Columbia, and that I have to sacrifice a lot of my free time and privacy.

> **My goal is to keep learning, because I'm nowhere near where I want to be.**

As you become better known as an actor, more people get involved in you directly and indirectly. You've got the "Suits" or " Bigwigs," as I call them, the "yes's" and the "no's." Sometimes, they want you to do things that maybe you don't believe in or feel like doing · like promos. I tend to follow my instincts and say, "No, I'm not going to do that." It causes trouble here and there, but I think the main thing is to be honest; to rely on your instincts and do what you feel is right and not always rely on what other people think you should do.

I think that in the beginning of an acting career, everybody wants to achieve notoriety or stardom. You want to be famous cause you want to be great at what you do and you want to be recognized for it, right? Now that I've been working for a while, being famous is not as important to me. My goal is to keep learning, because I'm nowhere near where I want to be. Like I said about the fame thing; if that becomes the motivation behind everything you do, even if you do achieve it, you're going to be stuck there and you are not going to grow as an artist. You're not going to go any further.

I don't believe in the whole "leading man thing" and "that's all he's ever going to do". I'd like to shave my eyebrow or my hair off or do anything. I want to hopefully with some of the roles I do later, make people see things in a different light so they won't just go with the flow in their daily lives, and feel they have to be or act a certain way just because, for instance, the President says, "That's the way it is." I'm excited to do as many different roles as I can.

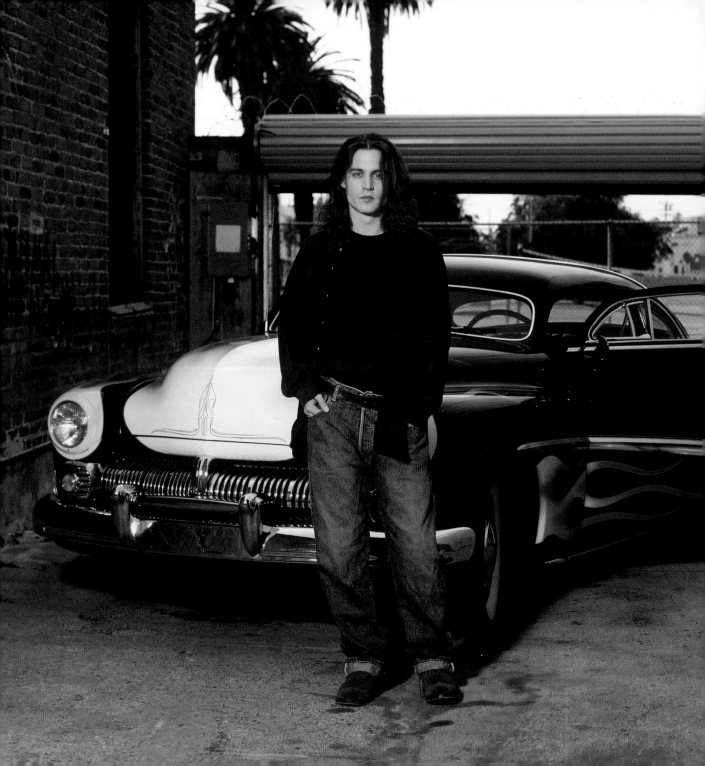

One of my favorite books right now, is Jack Kerouac's "On the Road". I try to read as much as I can. There are many books I've read that I'd like to film. I love the concept of "The Metamorphosis" by Franz Kafka. I'd like to become a giant cockroach. I love Van Gogh. I've always been interested in people who had mental torment-weirdoes. I think everybody is pretty whacked out in their own way. I deal with my anxiety by smoking a lot of cigarettes and listening to very loud music. I like Bach, the Georgia Satellites, Led Zeppelin and Tom Waits. When I was a kid I did drugs when I freaked out. I was in a rock and roll band in Florida, the cocaine capital of the world. Drugs are really prominent in the club scene, especially there. Drugs were hurting me physically and mentally. Drugs were dragging me down. They were killing me. I quit. Now I just smoke like a fiend.

I would never do a role that glamorized self-abuse or racism. Racism freaks me out. The black and white thing. The "n..... word" is still used constantly. Why is somebody who's black "a n..... word"? It doesn't register. Living in Florida, there are tons of rednecks out there - so many of these guys want to hear "Sweet Home Alabama" twenty-four hours a day. Racism freaks me out a lot.

The homeless are pretty important to me. There are a lot of people out there who have no food, no home and no money. A lot of them are there by choice but some can't help it. I wish some people with the big bucks, instead of buying a Rolls Royce or another Mercedes, would give a little scratch to the people who are hurting.

I don't know about sacrifices for becoming an actor. I think once you make that choice to be an actor, there is always a balance between good and bad. It's that thing of you've got to go through hell to get to heaven. In every good there is evil; in every evil there is good. Through everything bad that's happened to me, I've learned from it - which is OK. People usually think that if you're an actor and you're twenty-four and you look a certain way, you're an asshole. So they treat you like an asshole at first, then they realize that you're a human being and a nice guy.

As far as actors go, I like Marlon Brando, Jack Nicholson and Walter Matthau. I respect Nick (Cage) a lot. He's trying to go for something really different and he's in a great position to do that. He's very intense and he's got really innovative ideas. I think he's going to do a lot.

Why would a director choose me? I can only say that hopefully, there's something underneath my look or image that maybe hasn't come out yet. I want to try to do things differently. I want to experiment. I want to express different things at some point. It's just the beginning for me. I'm not even born yet as an actor. I'm still trying. I'm still pushing. I hope I never stop pushing. I don't ever want to get to a place where I feel satisfied. I think if I do that, it will be over. ★ JOHNNY DEPP, DECEMBER 1987

JARED LETO

In the summer of 1993, Jared Leto was sitting at a table outside one of his favorite hangouts, King's Road Café, which was also one of my haunts. I was having lunch with my mother, Charlotte, when she pointed out Jared to me. She said, "You should photograph that guy. He looks like one of your actors." When I turned around and saw Jared I knew she was right and went over and introduced myself. He looked at me with his penetrating eyes and told me that "Yes," he was an actor. At the time he was modeling and had just booked a Levi's commercial.

For a while we hung out together, going to screenings, parties and for coffee. Another one of Jared's favorite places to eat was Jan's Family Restaurant on Beverly Boulevard. I got the idea that he ate there frequently, mostly alone. He also liked to go to movies alone. I took him to Trinity, a trendy bar where Drew Barrymore's mother was the Maitre De and introduced him to Brad Pitt, who was with Juliette Lewis at the time.

At the point when I met him, Jared was doing well financially and had just bought a new red Isuzu Trooper with a killer stereo from which he blasted assorted rap music.

He was leasing a room in a modern apartment building on South Detroit Street, just down the street from where Ricky Lake was living. He impressed me as being a talented photographer himself when he showed me some photographs he took of a model he had worked with · the photographs were really wonderful. After forming a bond with my white boxer Oslo, Jared would call once in awhile to take him for a hike in Runyon Canyon.

One day, he called and told me he had found a great location for our photo session. He picked me up in his red Trooper and we drove to an area in downtown Los Angeles that reminded me of New York's Meatpacking district. The light was beautiful. It was fun to photograph Jared because he really participated in the process.

Jared's acting career took off when he landed the role of Jordan Catalano on Marshall Herskovitz's and Ed Zwich's acclaimed series MY SO CALLED LIFE. His subtle yet sexy performance evoked crushes from young girls across the country. Some of his career highlights include edgy roles in films such as GIRL, INTERRUPTED and REQUIEM FOR A DREAM. Jared's passion for music led him to form the successful band "30 Seconds to Mars" with his brother Shannon. He continues to channel his creativity into his art.

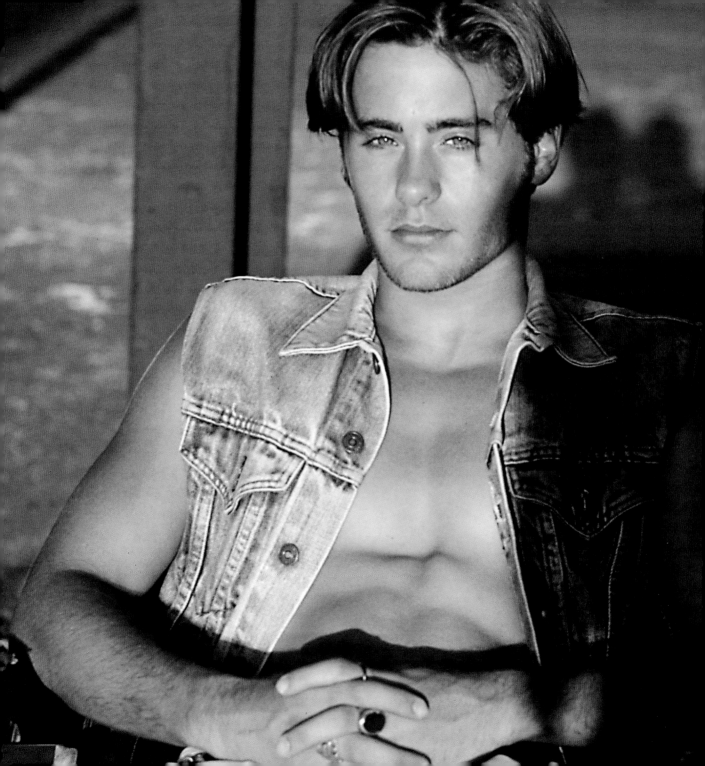

HEATHER GRAHAM

In 1988, Cory Feldman and Cory Haim invited me to a screening of LICENSE TO DRIVE in Westwood. It was there that I first met Heather Graham. A self-proclaimed "pretty normal girl". She proved it by only bringing one wardrobe change, a flannel shirt, to our photo shoot in Runyon Canyon. I lent her a black, sequined dress for the shoot. As fate would have it, years later, I would photograph Sandra Bullock wearing the same dress.

True to Heather's prediction, as she got older she landed better roles. In 1996, she was Lorraine, the hot girl across the bar, in SWINGERS. She followed that with a critically acclaimed performance as "Rollergirl" in BOOGIE NIGHTS. Finally, in 1999, Heather became a full-blown star as Felicity Shagwell in AUSTIN POWERS: THE SPY WHO SHAGGED ME. Since then, Heather has realized her dream of playing great parts in great films.

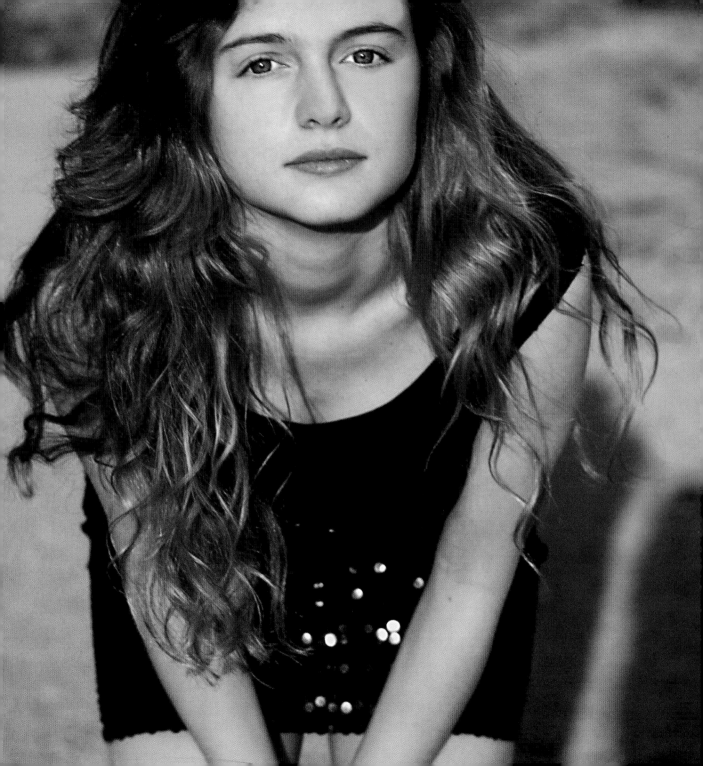

in her words

(HEATHER GRAHAM)

I think I'm pretty normal, I guess. I'm able to just be myself, but everyone has their own weirdness. In the acting profession it's easier to be yourself. My friend is a hippie and used to do computer work for a law firm, and when she would wear her flowing dresses to work they would send her home, or tell her to come to work at night because they didn't want clients to see her. As an actress, I'm not judged for being myself. It gives me freedom.

I think that you can make any role good. Even if you get "the girlfriend part." You can still make it something. But since most writers are men, most scripts are from their point of view, and most of the women are just the backups. I don't feel a lot of them understand women well enough to write them. There should be more female writers. It would be great to have roles out there that are truthful to how women are instead of how men see women.

Loyalty is very important in this business, and I believe that when people help you, you should stay with them. But it's also important to remember what your goal is, in the purest form, and to go after that goal in

There should be more female writers.

the way you feel you should. Follow your instincts. Remember why you started in the first place. My purest goal was to be an actress and be in great films and get to do great parts.

It was so weird when people in the industry really started to notice me. Before it was just, "Oh, she's just that stupid blonde girl in LICENSE TO DRIVE. Now it's "Oh! You're so amazing!" You see that one day people think you're so stupid, and the next day it's like God's coming. So you just don't believe what people say. You believe what you think. I knew that I always wanted to be an actress, and I know now that I want to work and be in great things. No matter what anyone thinks, I can keep at it long enough. And who knows what will happen? You can never be discouraged because someone else doesn't think that you can do something.

It can be hard to start off as a young actress; there are very few young actresses who really get great parts. I think Emily Lloyd and Winona Ryder get a lot of good parts. People see her and say, "Wow, you know, she can carry a movie." There are so many different ways to be an actress. My way will be working slowly. Just working hard and getting older. I'll probably get better parts when I'm older.

In some ways, I just think, "God, I just want to work." I think work is great and it's a good experience, but you have to be selective with the material you choose. A lot of my friends work all the time on a lot of different stuff, but I think it can be good to turn down roles sometimes. I want to work on things I'm proud of.

In the meantime, martial arts keep me centered and teach me discipline. ★ HEATHER GRAHAM, 1991

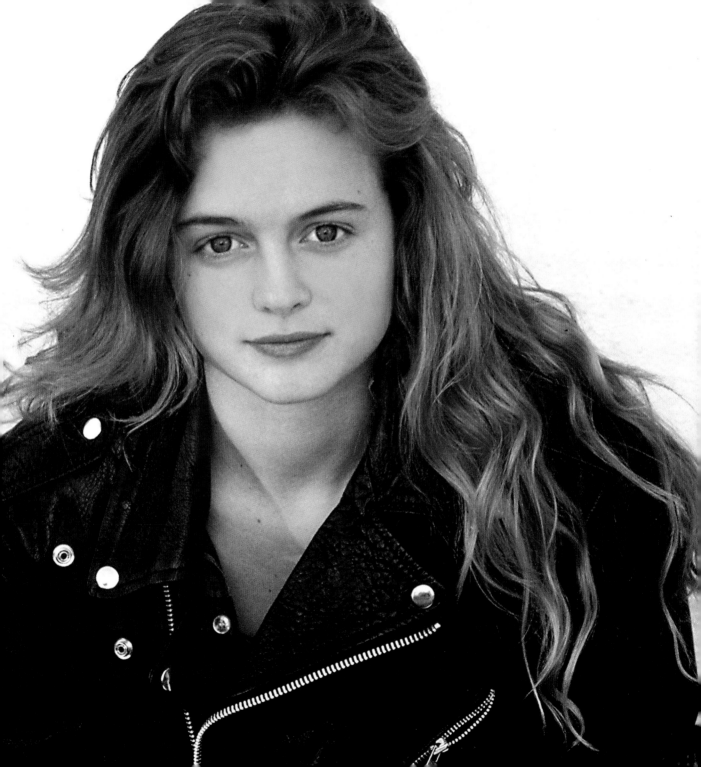

LAURENCE FISHBURNE

While at a trendy club on Sunset Boulevard, actress/model Lisa Marie, Tim Burton's one time live in girlfriend, introduced me to Laurence Fishburne. We sat next to him at the bar and Laurence and I struck up a conversation. He told me he was an actor.

I had been looking for a few talented multi ethnic actors to include in my book, THE NEW BREED. When Lisa Marie later told me that Laurence was incredibly talented and that he had co-starred in Francis Ford Coppolla's APOCALYPSE NOW when he was 16, I knew I had found who I'd been looking for. I went back to the bar and got his number. We met at my studio apartment on Franklin Avenue and I photographed Laurence on my rooftop. He brought with him some African garb. (That day was the first time I heard the term African American.) Laurence was a charming, down to earth guy with an infectious smile.

Since I photographed him, acting opportunities have completely opened up for African American actors. Laurence has gone on to tackle a wide variety of roles and has starred in classics like PULP FICTION. In 1994, he received an Academy Award nomination for his portrayal of Ike Turner in WHAT'S LOVE GOT TO DO WITH IT, and his role as Morpheus in the MATRIX TRILOGY cemented his place in pop culture history.

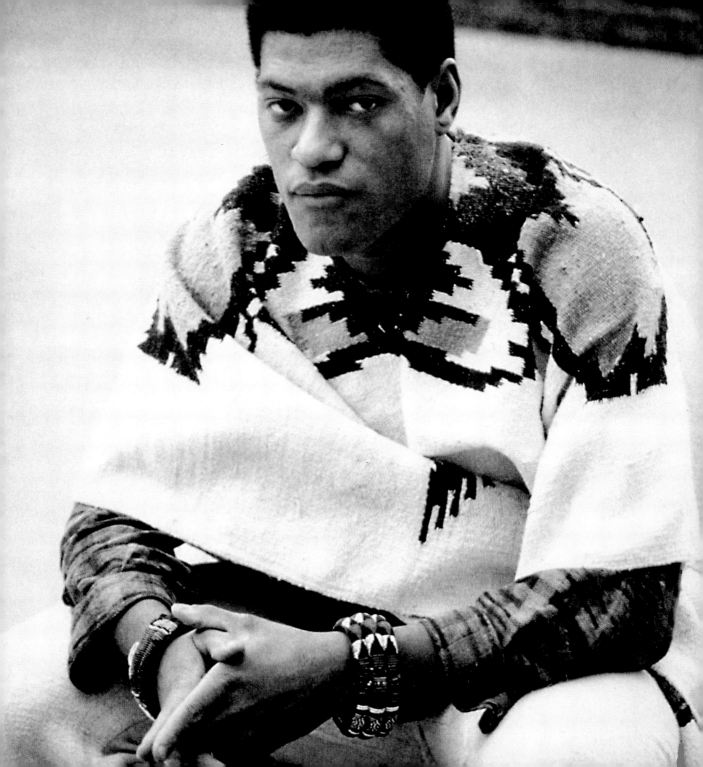

in his words

(LAURENCE FISHBURNE)

I'd use my acting prowess and fuck them up mentally.

I grew up at 19 Fiske Place in Brooklyn, New York. To get to my apartment, you had to climb up three flights of cold, gray, marble steps. I remember having to walk up those steps in front of my mother sometimes, when I was bad at school. It would be like the longest walk in the world.

We lived in apartment 3C. Our bedroom faced the street and at three in the afternoon you could always hear kids outside playing stickball, roller hockey, tag or whatever. My house was always filled with the incredible aromas of African American cuisine: fried chicken, chitlins, greens, grits, biscuits, bacon, and occasionally lasagna. I had an Italian friend; whose house I would go to for dinner a lot and I grew very fond of lasagna. So my mother would make it once in a while. My parents had separated when I was three and got divorced when I was 10. I was an only child. I saw my dad at least once a month, on Sundays, and we would go to the movies. When I got back from the movie at 6 PM, I would act out the movie I'd seen for all the kids on the block. Most of them came from large families so they couldn't afford to go to the movies. That was my first experience with acting.

I've been acting professionally since I was ten but I didn't start to take it seriously until I was 16 or 17. Up until that point, acting was something I enjoyed and was good at. It was also a way for me to survive. I'm not a very physical person and growing up where I grew up, there was ample opportunity to get into physical confrontations. Instead of saying, "Well, I'm gonna kick your ass," I'd use my acting prowess and fuck them up mentally.

The experience that changed the way I looked at acting was working on APOCALYPSE NOW with Francis Ford Coppola. I began to look at acting as an art form. Francis looks at film as something that hasn't even begun to be tapped the way it ought to be. The film business, i.e. Hollywood, hasn't utilized the medium to its fullest potential of doing wonderful things with a new art form.

There is also a peculiar problem I have had to deal with every day of my life. The problem is called racism. Regardless of all the wonderful work I've done and will do, the fact remains that I am African American. I am a black person. There are hundreds of scripts that go out to white actors that I will never see. The majority of stuff I get sent on says "Black", which is why I don't get submitted piles of scripts. There are just, not that many of them. I don't have the flexibility to look at certain kinds of roles. If I'm available to go out and do a role, what I try to do is make sure my vibe is a vibe that any young black American or black man on the planet can relate to in a certain way. I do that because, after all, that's what I represent on the screen. Racism is a bitch. It exists, and I just have to do the best I can. When I got back from APOCALYPSE NOW, I was 17. Everyone said, "Larry, you'll work all the time." If I had been a

white boy I'd be making more than Charlie Sheen, based on talent alone. That really fucked me up for a while but I go with it. At least I'm working.

When a cat sits down to write a screenplay, he's concerned with his story and his primary characters. The rest of it is not as well thought out. For a white cat to write a story that has black characters in it, there's no telling how much he knows about black people. Once upon a time, I used to shake my head and say, "This is bullshit." I don't expect him to have a clue anymore. How could he have a clue? Since I have all the baggage about that, I just bring my bags. To make it as a black actor you have to work hard, stick around and deal with people as people. It can be really frustrating sometimes. I just used to deal with my frustrations by getting fucked up a lot. Now I just work through things and try not to let it interfere with my work. It's like that line in HARVEY when Jimmy Stewart says, "You can be, oh, so smart, or, oh, so pleasant." At work, I try to be "oh, so pleasant." In life, I try to be "oh, so smart."

Working with Spike Lee on SCHOOL DAZE, I got to be pleasant and smart. Spike passed me the ball and said, "Run with it, homeboy." The film is about black people and there's a difference. Aside from the pigmentation there are cultural differences, language, speech patterns, body language. All black people don't talk the same. There are cultural differences among us. This was my first opportunity as an actor to really let loose.

There's a possibility that SCHOOL DAZE will open up a lot if doors for me but there's also a possibility that people will say, "That was nice, next." I'm prepared for that. I'm still prepared to play the third character in someone else's movie. It really doesn't matter because I'm about my craft. That's what I take seriously. Actors I know sit around all the time and have discussions about acting and this one and that one. "That cat," we say, "is weak." Why? Because he's not about the craft. He's about all that other starry eyed shit.

I like it when I meet my brother on the street and that cat says, "My brother, I like what you're doing in the movies." My biggest fear is becoming very successful and recognizable and not knowing how to handle it. That's another reason I've always been into being an actor as opposed to wanting to become a star.

The reason it's important to me that my people recognize me, is that people of African descent in this country and in a lot of countries around the world get bombarded with negative images of themselves. That goes back to, "Why does the black man always have to play the pusher, the pimp and so on?" The reality is that a lot of us still do that. I fight racism by trying to be right as rain and by promoting a positive self-image. That's what I'm doing to make a difference in the movies, and that's what I'm doing to make a difference in the world. ★ LAURENCE FISHBURNE NOVEMBER 1987

KEANU REEVES

RIVER'S EDGE, a film about apathy among America's youth, had a powerful affect on me. Keanu Reeves, one of the film's stars, stood out in particular. Keanu described his character, Matt, as young and greasy, but also beautiful and hopeful. Inspired by his performance, I contacted Keanu through his manager, Keith Addis. Keanu greeted me outside his two-bedroom apartment in Los Angeles, which he shared with a roommate. The apartment felt like a college dorm. Clothes were strewn about. Empty glasses and a bottle of red wine littered the table.

I photographed him in a parking lot nearby. He parked his 1969 Volvo with novelty 007 Ontario plates there. A year later he crashed the car and I would see him cruising around on a Norton motorcycle. When we finished our shoot, Keanu played his favorite record for me, "The Butthole Surfers". Francois, my makeup artist, winced, but, as Keanu wailed about, I could see that the music touched him to the core.

I kept in touch with Keanu for a few years and once went to see him play with his band "Dogstar" at San Diego's Belly Up Tavern. Their music, influenced by "The Butthole Surfers", rocked the venue and Keanu's focused and unphased stage presence rocked the crowd. Girls screamed and threw their panties at him. After the show, Keanu, sporting a short haircut for SPEED, greeted me with a kiss. In the late 90's, Keanu filmed the first installment of the MATRIX trilogy. The film became an instant sci-fi classic and assured Keanu his place in Hollywood history.

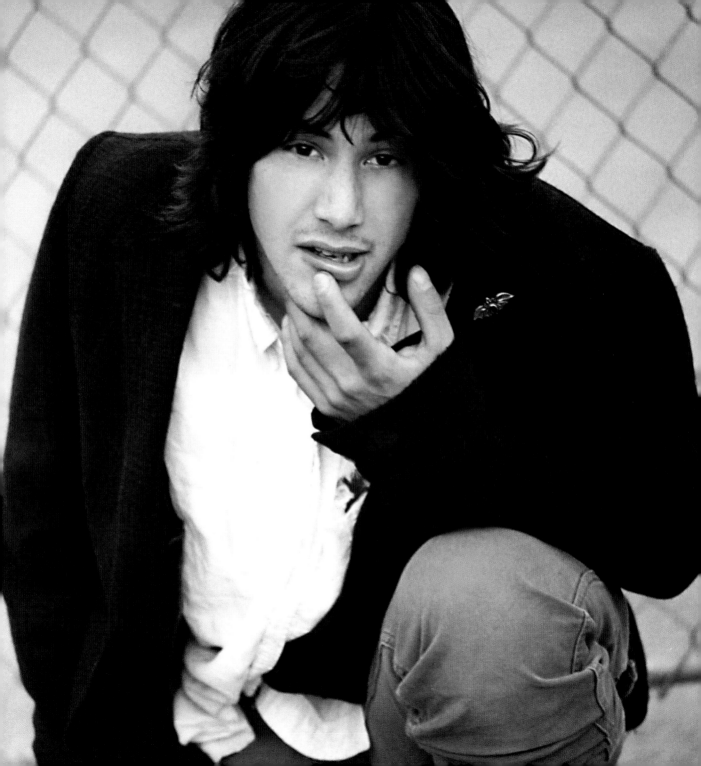

in his words

(KEANU REEVES)

I grew up with my mother in Toronto. There was a time when we didn't have any money. All of the bags in our cupboards were yellow and black, 'cause that's what generic food brands are in Toronto. Somehow we ate and maintained a lifestyle that was OK.

I went to four different high schools. When I got out of grade eight, I picked the school that was the best academically even though I wasn't a very good student. I was the only one from my school that went there. Bang, it was a whole new world. The agony and ecstasy that was grade nine. One day, in grade 10, a friend asked me to go along with her to an audition at the Performing Arts High School. I auditioned and got in. I was happy; and then I got kicked out. I guess I was a little crazy then because it was grade 11, and I was acting and it was weird. I got kicked out because I was a little too rambunctious and shot off my mouth and was generally not the most well oiled machine part of the school. I wasn't really a loner. All through high school I was always in plays and on the basketball team and in the chess club. My last year, I went to what they call free school and held a part time job making pasta.

Deciding to become an actor didn't really happen until I was 17 or 18. I started taking acting classes at night, mostly out of respect for acting. I was taking classes, and playing hockey a lot, and I started crashing auditions with friends from the Performing Arts High School. I got some jobs, and then I got an agent, and it all sort of fell together. I started doing community theater and commercials. I did a Coke commercial and I did this killer Kellogg's commercial." My first big acting job was in a play in Toronto, called "Wolf Boy". I played Bernie, a suicidal jock who goes into an insane asylum.

I moved to LA two years ago. I was in Toronto and had come to a point of doing most of what I could do there. The theater community and I weren't really ready for each other. I was 19 and full of energy and I would go to the auditions and they'd say, "Great, great, maybe next year." I was tired of playing the "Best Friend", "Thug #1", and the "Tall Guy". I'd gotten an audition for a movie of the week for Disney called YOUNG AGAIN, where I was reading for "Best Friend #1", but the director liked me and had me read for the lead. In LA, I met Hildy Gottlieb at ICM. She told me, "When you get your act together...come and see me." Eventually I got the job and a green card and I was legal. I got in my 1969 Volvo and drove out here with $3,000. I stayed at my stepfather's and proceeded to go into the darkness that is LA.

Then I did RIVER'S EDGE and a film called THE NIGHT BEFORE. It seems to me that in Hollywood, you have to do a quirky comedy to lose your cinematic virginity. I've done a couple of them. I just finished a film called BILL & TED'S

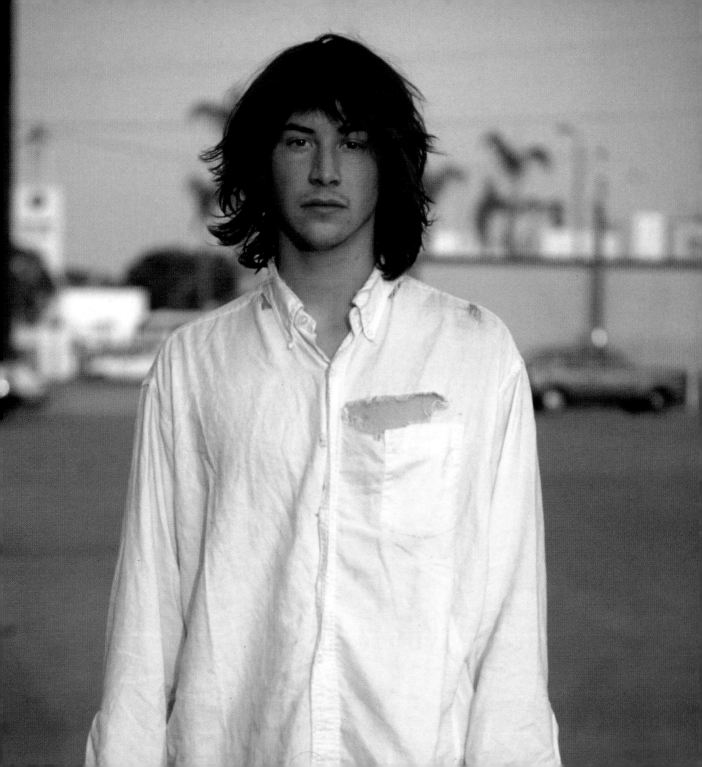

EXCELLENT ADVENTURE. Lots of time traveling, mind bending and twisting. It's cool because there's no swearing and hardly any violence. There's some dark innuendo in it. I hope it's funny. We changed it a lot and I think for the better too. That was an experience of having fun and working and trying to do it, and hopefully succeeding. Stephen Herek was great with us and the other actor, Alex Winter, was inspiring. I got to play a guy who's like a child of nature. He's almost an idiot savant, except he's not that smart, but he's pure and good. He's a good soul.

I jumped into acting without an ultimate goal. It was something I wanted to do and I realized recently that if I don't have goals people are really going to fuck with me and I really hate that. Now my goal is to do good work. I figure with the scheme of being in Hollywood now, with my life as it is, I would like to play a very neurotic, crazy, evil, mean character. I'd like to play someone that's just fucking ugly. Oh, my goals in general · to get better at the bass. I picked it up a year and a half ago.

Most scripts I read are bad. Hollywood's a strange place. A lot of what you're going to see is quasi-literal entertainment. It's hard to bring new ideas when they're out to make money. Wow, man, what do I look for in a script? I totally want to be enlightened, dude; interesting stories, interesting people, characters, development, ideas being proposed, clash, conflict, hate, love, work, death, success, fame, failure, redemption, death, hell, sin, good food, bad food, smells, nice colors and big tits.

What roles am I looking for? Someone really evil, dark and ugly. Most of the characters I've played so far have been very good people. They all have a certain innocence and naivete, and I think I'd like to sort of explore other stuff. Hopefully soon I will be a major asshole coming to a theater near you. Body, spirit, balls and toe jam.

What kind of preparation do I do? It's so abstract. Acting is such a weird fucking thing, man. For every role and every beat it's just so different. All I can say is that I try to give, and I try to learn.

Do I do preparation? No, I treat it lightly. I just basically look over what I have to do the day before and if I don't have time, like if I have to vacuum or something, I do that instead. Me? Of course. How can you not?

I would only do a nude scene if it was a good nude scene. I won't do superfluous nudity. Are you asking whether or not I'm embarrassed about my body? Sometimes (laughs). I would take my clothes off in front of the camera if I were comfortable with it.

I'm 23, and I've been studying since I was 16. My studying had been fairly nomadic and of a fairly wide range. I went out to Pennsylvania for a summer. There was this house in Rose Valley. All the actors lived in the house. The theater was just a quarter mile down the road. You just hung lights, did box office and studied five hours a day. That

was intense. So, yeah, studying is important.

My manager and agent all serendipitously came together. I thank the Gods. One thing that's cool about being in Hollywood and doing movies is that somehow if you happen to be in a film that makes a lot of money, you get power. I don't want too much power, man. I don't want to be like Eddie Murphy, being so far out there that it is no longer feasible to be an actor. But I would like to have enough things so that people would be curious. I'd like to have my say and not be screaming at the walls.

I guess I'm successful in that I'm getting a chance to do what I want to do. What sacrifices have I made to do that? I don't know if they're sacrifices, because I've gotten to do what I wanted. Privacy. Yeah, man, obviously because its public domain. You're in a movie and people see it. That's not a major thing for me. I haven't experienced fame yet. I'm not really out there yet. Life hasn't really been affected by that.

How much does my image differ from who I am? I'd like to say that I'm not all that naive, but I am. And I'd like to say that I'm not all that innocent, but I am. In terms of misconceptions about me, probably that I'm clean or that I'm short.

I guess I'm successful in that I'm getting a chance to do what I want to do.

What do I like best about acting? I almost said, "Chicks and sex and fucking and money," but that hasn't happened yet. The best thing about being an actor is acting. I mean, what else is there?

I've been recognized on the street about 12 times. I feel like a young pubic hair. I keep getting checked out and played with sometimes. The heaviest thing actually happened to me, two days ago. I met this kid, who's about 17, who looks just like Matt, (Keanu's character in RIVER'S EDGE) and he said, "Whoa man, you're my idol," and he gave me all this free food and shit at the restaurant he worked at. That was cool.

Who would I like to play on screen? The young part of me would like to play Rimbaud. Imagine, someone who's writing sonnets in Latin at 17, telling his teachers that they're full of shit. By 20, he's totally disillusioned, and leads a life of debauchery and dies in the gutter. That sort of appeals to my artistic, cool, deep side. There are others. Rimbaud just came out of the top of my head. Movie remake? Anything I say is obviously a snapshot and in this snapshot, I would say THE RULING CLASS.

Oh man, if I have to talk about spirituality, man, I have to get more wine. In the gutter is man's essence, in the

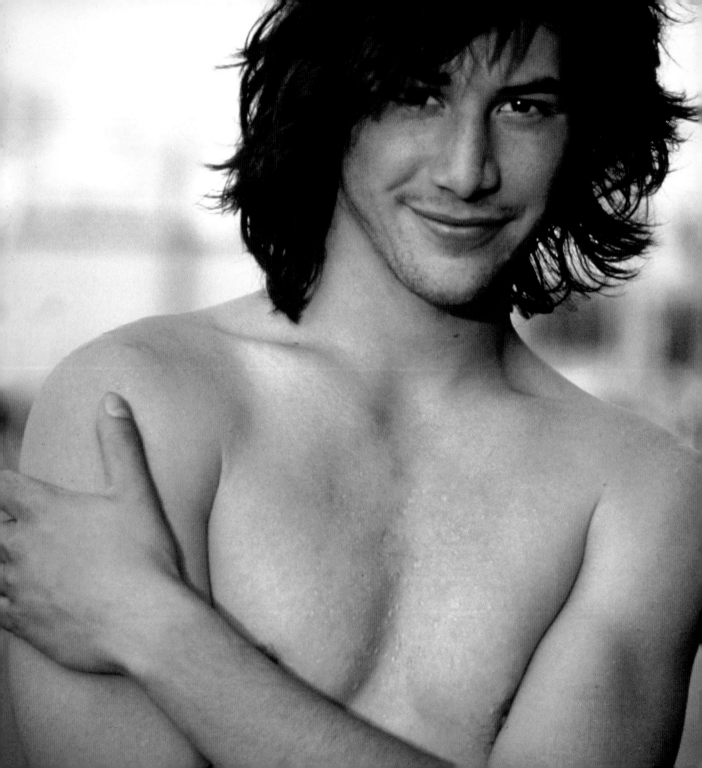

essence is the gutter of man. Well, I don't involve myself in organized religion. I checked it out when I was 11. Since then I haven't needed it. I totally don't want to bum anyone out. Here we go, God! My own God? Do I believe in my own God? Well, I seem to pay petty respect, whenever I talk about my success I talk about retribution for my success, that you must pay for it. I guess, in some sort of deep rooted way I feel I haven't. I don't agree with that. Maybe I'm paying tribute to irony. It's the sort of thing that can make you bitter. But, yeah, I guess I believe in God. I don't know. These are things that are still in turmoil.

My biggest fear is that my underwear will have a stain on them if I'm ever with a woman that I've never slept with before. That's a major fear. I'd rather laugh than be in the corner crying. But, you know, everything is a flash, man. All I can say is that I'm 23, and there's a poem by Walt Whitman that goes, "In my youth I thought long, long thoughts." I am sort of a sensory hound. I've been a sensory hound ever since I can remember.

I used to live my life out of a basket. I would make money from a commercial, and put it all in a basket. I'd go to the bank and say, "I'd like to cash this check for $4,000." They'd go, "Wouldn't you like to open a checking or savings account?" I'd say, "No, man, just give me the money." For the next year I'd live my life out of the basket. But things got complicated. And when things get complicated, I bail. Even when I was poor, I had accountants do my taxes. I have no idea and no interest in paying attention to that (money matters). I live very simply and that is something I want to do. I'm basically a very rudimentary fellow.

What actress would I most like to play opposite? Oh, I don't know, man. Who would I like to fuck the most? Meryl Streep because even if I wasn't that good, she would fake it the best. No, I haven't slept with most of my leading women. I'm practically a celibate monk.

This is what I think is happening with actors in Hollywood. A lot of people that I've worked with have this sense of darkness and sticking to their guns with their point of view of acting. I think that there are a lot of heavy actors that are going to surprise people. They are sincere and generally well bred and smart about what they are doing. We are getting more theatrical in our acting styles, in the sense that we are taking more risks. John Cusack is an example of someone who we haven't seen pull the bag out of the hat yet. He is representative of someone that is going to do it because of the market, but will probably end up doing something where we go, "Whoa, hey!" I hope so, because I'd like to spend six bucks and feel it was worth it.

How do I fit in? I guess I'm just doing what I'm doing, trying at least. I'm trying to pursue what I'm curious about. Trying to survive and hopefully not be fucked up the ass by irony and the Gods. ★ KEANU REEVES, SEPT. 1987

BRENDAN FRASER

One day, I received a call from Brian Swardstrom, a talented agent whom is now a film producer and a partner at Endeavor. He wanted to show me an audition tape of an actor he was thinking of representing. I was initially convinced that it was a young Puerto Rican guy doing a monologue, but in fact it was Brendan Fraser, a Caucasian from Canada. Brian was very impressed and brought him down to Los Angeles from Seattle where he had been residing.

I photographed Brendan's first headshots in LA. It took him a year or two, but Brendan was soon on his way towards a thriving acting career. In the nineties, Brendan starred in a string of successful films such as ENCINO MAN, SCHOOL TIES and GEORGE OF THE JUNGLE. He transitioned into the action genre when he starred in THE MUMMY trilogy and continues to deliver powerful dramatic performances in films like THE QUIET AMERICAN and the critically acclaimed CRASH.

In 1995, I cast and photographed an Edwin Jeans campaign for Japan, where I had a chance to work with Brendan again. We chatted about what was going on in his career. Brendan is a down to earth, charming, funny guy and a talented actor who continues to challenge himself with a wide range of roles.

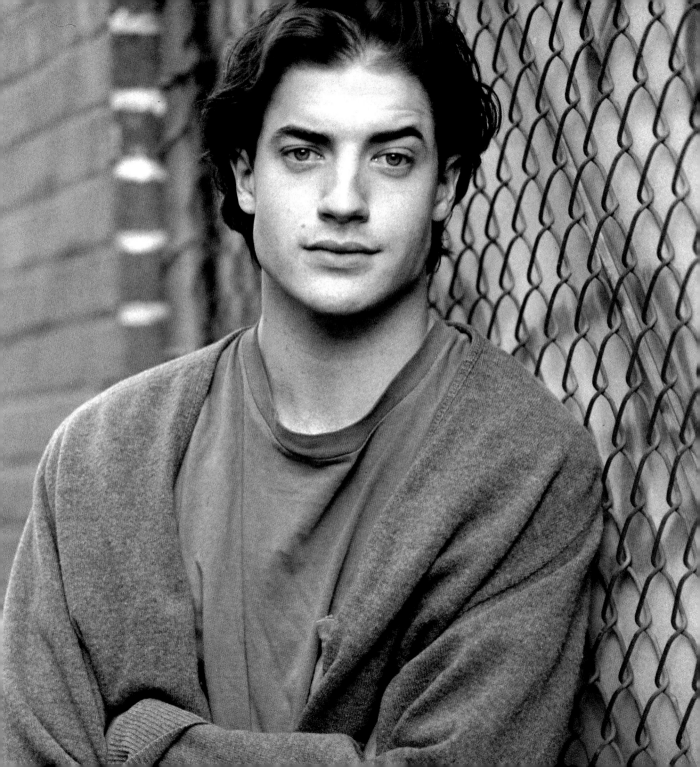

(BRENDAN FRASER)

I just finished a film called AIRHEADS with Fox. It's a comedy about three rock and rollers who take over a radio station to get their demo tape played. They don't mean to take over the station, it happens by accident. But then the cops show up and they have a hostage situation on their hands. I play Chaz, the band leader. Chaz has very long hair. It was really fun. I learned how to ride a Harley Davidson for the role so we could look cool, even if we don't sound cool. And I have another movie out called WITH HONORS.

Steve Buscemi and Adam Sandler were in AIRHEADS with me, as well as Joe Mantegna, who is my hero. There are cameos from other rock guys too. I think the soundtrack is gonna be great; "Anthrax", "Metallica", and "The Ramones" are all on it. WITH HONORS is about a homeless guy who steals my character's thesis and through getting it back, they become friends. They forgive each other and are able to reconcile their differences. Joe Pesci plays the homeless man. Patrick Dempsey is also in the film.

It means to me the paint that an artist would use to create his works, only films are what I use to create.

Acting, to me, means I can pay for this sandwich that I'm eating. It means to me the paint that an artist would use to create his works, only films are what I use to create.

My lifestyle? I do my own laundry. I frequently eat pre-packaged food. I have yet to change the nozzle on my shower. THE APPLE DUMPLING GANG affected me the most because that's the movie I saw first. So far, the favorite movie I've been in is SCHOOL TIES, because the issues presented in the film are resonant today - namely that we need to accept one another.

My favorite music recently? I've been listening to a lot of Bjork. Her voice is haunting. I like all types of music though. I don't discriminate, whatever's contemporary.

What do I do in my free time? I traveled recently. I went to London and New York. I saw some plays, went to museums. I've been to a couple of premieres. It's fun, but I have the most fun when I'm working.

What jeans do I wear? Levis. ★ BRENDAN FRASER, 1993

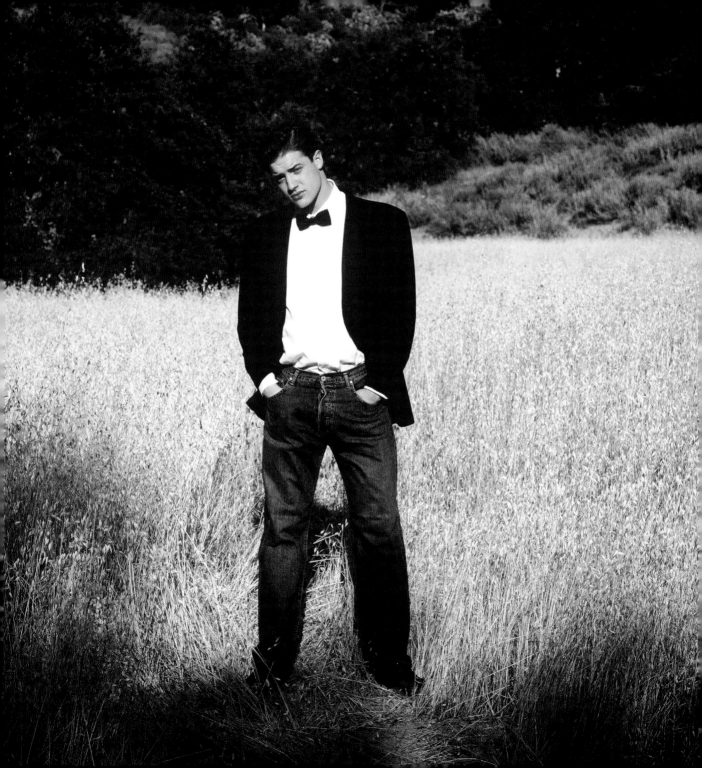

SANDRA BULLOCK

Sandra Bullock was my neighbor for three years. I first met her in January 1991, through her houseguest John Ryan. She had just moved into a spacious, ground floor, two-bedroom apartment around the corner from me on Sierra Bonita near Melrose Avenue.

I was first struck by Sandra's "old movie star" looks. She reminded me of a cross between a young Katherine Hepburn and Lauren Bacall. As I got to know her it became clear that she was unfazed by her beauty and very down to earth. I saw that she was unaffected, ambitious and amazingly confident. There was no doubt in Sandra Bullock's mind that her career would go forward and everyone around her believed it too.

I knew that she was going to become a huge star. Her dedication, drive, uncanny facility to manifest her own destiny and her ability to get others to believe in her were a powerful combination. I had been working on a Japanese campaign for Edwin Jeans, for which I had cast Johnny Depp and Brendan Fraser and I tried to convince the ad agency to use Sandra. To my frustration, they felt Sandra was still too much of an unknown.

At the time, Sandra had a miniature Yorkshire terrier puppy named Monster. John complained constantly because Monster would poop all over the apartment and he would have to clean it up. Sometimes, I brought over my dog Oslo, a white boxer puppy. Watching them play made us laugh. Oslo would pick up Monster and throw her around, but it never deterred Monster, who would always come back for more. Eventually, Sandra rescued another dog, Pony, and they all moved into a house with a yard on Detroit Street. On one of our dog walks, Sandra asked me about Keanu Reeves. Having seen his portrait in my book, she was intrigued with the possibility of working with him. Only a few years later, they would star together in the blockbuster SPEED.

One day, Sandra and her boyfriend at the time, Tate Donovan, asked if I knew of an apartment for rent. As it happened, a beautiful apartment in my building was available. Tate soon became my neighbor and I saw Sandra more often. When I mentioned to her that I was studying German, she revealed that she spoke the language fluently. Her mother had been a famous German opera star and Sandra and her younger sister traveled throughout Germany during their childhood. After that Sandra occasionally would help me with my homework.

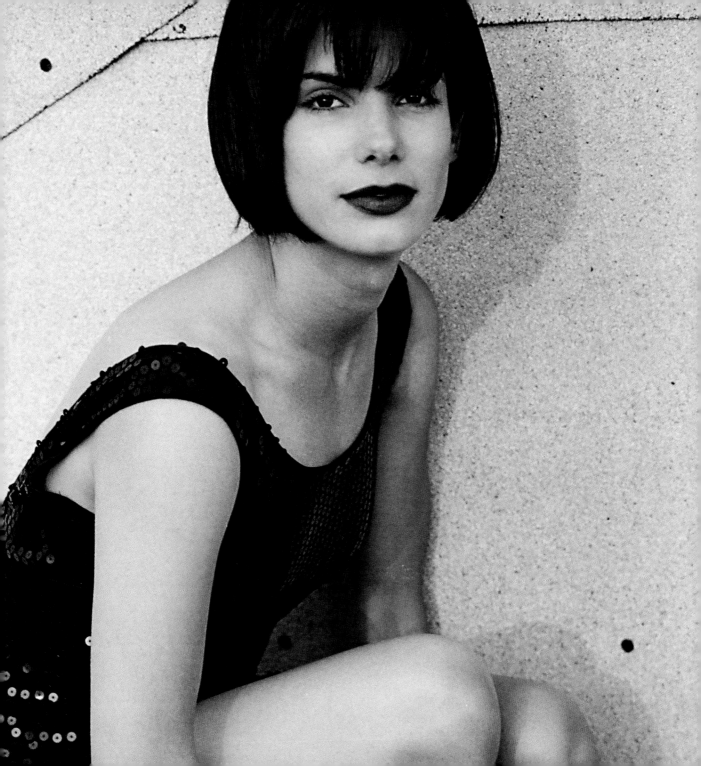

Rock climbing was another one of Sandra's passions. Often, she went with friends to places in the high desert, like Idyllwild. She celebrated her birthday with a big party every year, loved to dance, was a great hostess and always made sure that everyone was having a good time.

Meanwhile, Sandra was cast in a small independent film, WHEN THE PARTY'S OVER, written by a mutual friend. I took Brian Swardstrom, a friend who was an agent, to the screening, and he agreed that Sandra had something special. Sure that her next film, LOVE POTION NUMBER 9, co-starring Tate, would bring her to another level, Sandra discussed hiring me to do publicity shots. Unfortunately, the film was not the box office success she had hoped it would be.

In 1992, Sandra wanted to see how she looked in a short wig and asked me to take some photographs of her. Since I had always wanted to photograph Sandra in a glamorous way, I lent her a black sequined dress. She did her own makeup and, along with Oslo, we proceeded up to my roof. Later, Sandra asked me to photograph her in a more natural way. She wore jeans, a white t-shirt and swept her hair back in a French twist. We often spoke about doing an interview, but kept putting if off since we were neighbors who saw each other so often and never got around to it.

Eventually, Sandra was cast opposite Sylvester Stallone in DEMOLITION MAN, taking over the role from another actress who apparently was not sexy enough. My husband Fredrik and I attended a party she had to celebrate her success. SPEED followed shortly after and sure enough, Sandra Bullock had arrived. The box office success of WHILE YOU WERE SLEEPING propelled her to superstardom, a major feat for any actor but especially for a woman in today's Hollywood.

John Ryan and Tate used to joke that Sandra never had a bad audition. When they would ask her how it went, she always said, "It was great, it was great." Whatever the audition was for, even if she didn't book it, she always managed to find something positive, and would never concentrate on the negative.

I once visited Sandra at her last rental house on Sierra Bonita above Melrose Avenue while she was on the threshold of major success. She was on the floor scraping her bathroom walls while greeting me. When her phone rang the answering machine switched on and Robert Duvall's voice echoed through the house. They had just worked together on WRESTLING ERNEST HEMINGWAY. Upon hearing his voice, she dropped her scraper and picked up the phone. That was the moment I realized that Sandra was well on her way to fulfilling her dream.

Since then, Sandra Bullock has manifested her success and become one of today's highest paid female film stars and producers. Her production company, Fortis Films, has executive produced the mega-hit MISS CONGENIALITY and the hit television series THE GEORGE LOPEZ SHOW.

To her credit, Sandra generously gives back to the community by actively volunteering and donating money to worthy causes. After Hurricane Katrina, she donated one million dollars to The American Red Cross. Sandra is a testament to the fact that positive attracts positive.

I'm delighted that Sandra has finally found stability and true love with Jesse James, her tattooed Monster Garage hero.

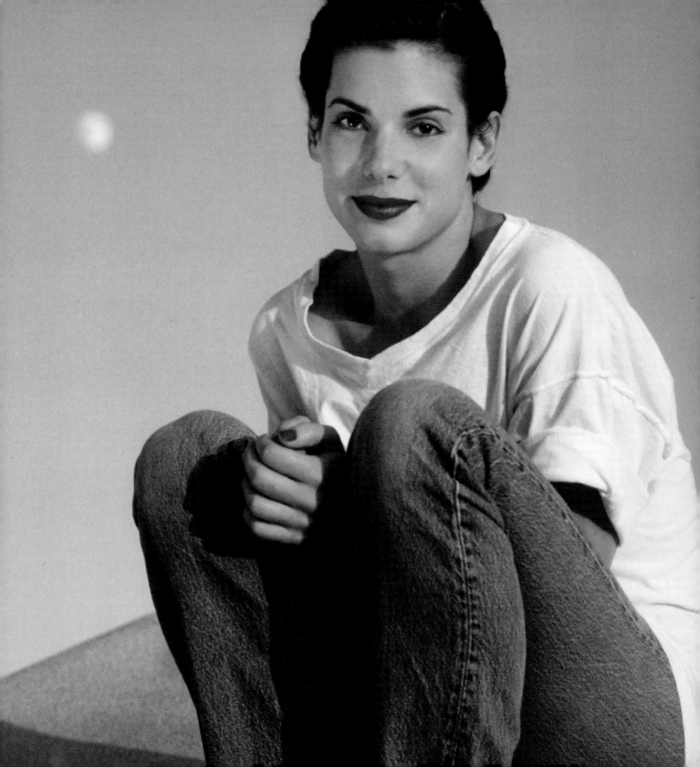

PATRICK DEMPSEY

Kevin Koffler, a talented writer I had been working with first told me about Patrick Dempsey, whom I then met at a diner in the New York City neighborhood of Chelsea, before our photo shoot. True to his image, he was an extremely sweet guy. After the shoot we ended up on my roof with him hugging my adopted Akita. At the time, Patrick was a student of Gurumayi and practiced Siddah yoga. Often meditating for many hours in a single sitting, he says his career did not take off until his guru opened his "divine inner energy". During that time, he also overcame a serious case of dyslexia, mastering reading and writing for the first time in his life. Though Patrick had starred in a slew of independent films, he felt that he was just starting and still had a lot to learn.

Fifteen years later, Patrick was cast as Reese Witherspoon's fiancé in SWEET HOME ALABAMA. Hollywood came knocking and in 2005, he was cast as Dr. Derek Shepard in ABC's GREY'S ANATOMY. Almost overnight, adoring fans knew him as McDreamy. Since GREY'S, his feature film career has flourished with starring roles in ENCHANTED and MADE OF HONOR. His boyish good looks have matured and his rugged handsomeness earned him People Magazine's "Sexiest Man Alive" to ad campaigns for Versace and Avon. Now, Patrick Dempsey is a bona-fide sex symbol, mega-star · and all around sweet guy.

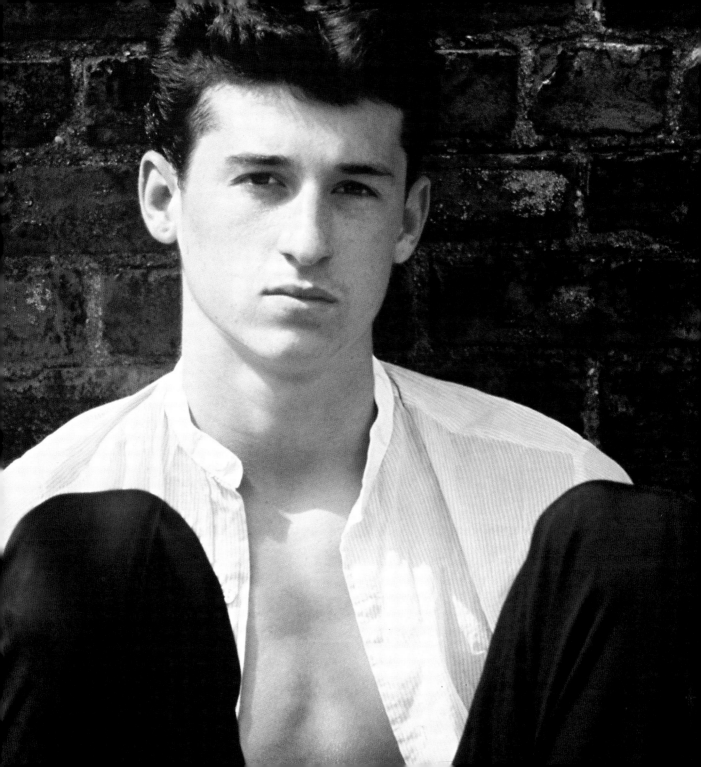

What I remember most about the house I grew up in was the sound of the cars racing by. Whoosh. Whoosh. The garden. The wind blowing through it. Wishing the wind would pick me up and carry me away. Wanting to be somewhere else. My tree house. It's an old apple tree, sort of like an old man with one arm missing. It just leans out and reaches up to touch the sky. The elbow is connected by a string hanging down and a plastic tire that was bought at Sears. I swing on it, but I never really like it because it isn't a real tire. From my tree house, I can see everything. It's my control tower. I play with my GI Joe's. If they fall off, they die. One time, a GI Joe's arm falls off and I pretend he's an amputee from the war. In the wintertime, I can jump off the elbow of the old man like a paratrooper. I can fly for a few seconds.

> If you were to ask my friends in high school what I was like, they would probably tell you I was weird.

Once, I ran away to my tree house. It was a Sunday, in the middle of February. It had just snowed but the sun was out. I packed up everything that was important to me: my GI Joe's, my stamp collection and a few clothes. Dinner was being served but I didn't want any. The house was filled with the smell of roast beef, served every Sunday at the same time, which I hated. I had my Donnie & Marie lunchbox filled with cookies. I put on my jacket and marched out the door. Everyone took me seriously. They said, "Go. Good luck." I sat in the corner of the tree house shaking. Five minutes seemed like a lifetime. What was I going to do? I went back to the house, dejected. I had failed at a young age.

If you were to ask my friends in high school what I was like, they would probably tell you I was weird. I think that sums it up. They thought I was weird because I was into juggling and riding a unicycle. I was more into different things than most kids in Buckfield (Maine). I remember when I had my hair parted down the middle, when it was big and everyone thought I was gay. When they asked me if I was gay, I said "Yes" to piss them off but I was never really gay. I though it would be a great ploy to get girls, because they would try to convert me. I was wrong. It backfired. Back then, I wanted to be a ski racer. I was the State of Maine Champion. I saw Ingmar Stenmark in the 1984 Olympics and he was riding a unicycle and I decided that's what I needed to do to improve my skiing. Through the unicycle, a shop teacher named Paul McKinney introduced me to juggling and one thing led to another. I entered

a competition called Talent America. I had a three-minute juggling/comedy routine. I won the Maine preliminary and I went to New York City for a national talent competition, hoping to get an agent so I could start auditioning for plays. I ended up winning and I got a huge trophy as well as an agent. A few weeks after I won, my new agent asked me if I'd fly down to New York City to audition for the San Francisco company of TORCH SONG TRILOGY, a Broadway play. I said sure, but I had no idea of how I'd afford to get down there. My dad took a loan out of the bank. I went, auditioned and got the part. I never really went back home to Maine after that. I usually say I ran away, because it sounds more glamorous, and I like it that way. But the truth was, I had the opportunity to do TORCH SONG TRILOGY, and I saw it as my ticket out of Maine. I just felt Maine was too confining. Nobody had wild, crazy ideas. They didn't have any vision. You'd go to college and get married. It wasn't something I was into. I didn't really fit in; but then again, I didn't work too hard at trying to fit in. It just wasn't rewarding enough. I made an attempt early on, but I wanted to do my own thing. And doing my own thing in Buckfield, Maine, meant not fitting in.

When I started working on TORCH SONG TRILOGY, I was a Maine hick. I was really naïve. I was 17, but I looked like I was 12 - doing a gay theme play in San Francisco. Homosexuality freaked me out. It was new to me, and I didn't know how to react. The people in the company were really warm, so I eventually started to relax. I didn't experiment at all because I had just lost my virginity in Maine and that was a big thing for me. I was looking at girls. I'm more aware of what that whole experience was now, then I was back then. I was open to it all and I couldn't tell who was gay and who wasn't, but it didn't matter. What difference does it make, anyway?

When I first started out, my goals were to get as many girls as possible, drive the biggest car I could buy, and become a big movie star. That lasted about a year. Living like that was taking me further and further away from acting, and I didn't even realize it at the time. It wasn't until I met my acting coach, Rocky, that I began to get a real understanding of acting. Everyone in America is lead to believe that being an actor is about having big cars and living a fast life. Now that I've been through all of that, I know that's not what its about. I worked in Hollywood because I got by on my cuteness, but I got terrible roles. I did this horrible movie called MEATBALLS 3. It was awful. I was ordering Dom Perignon, and thinking I was the coolest, hippest guy. Meanwhile I was a real asshole because I didn't know about feelings. I didn't know who I really was, and I didn't understand what was going on.

I was sleeping on the floor of my friend's apartment in New York City. I was irresponsible, running away from all my problems and avoiding dealing with anything. I was broke and getting further and further into the hole. I started hanging out with the wrong people with the drug crowd, which I didn't need. I was hungry for someone to hang out

with. I was a new kid from Maine, getting caught up in all this stuff. I was lucky it was six months, or a year, instead of six years. I had to go through that though, in order to respect what I have today.

My goals are not about making money, anymore. I like money. Who doesn't? But my goal is just to work and to try not to get too caught up in the Hollywood element. I think you can live in Hollywood and not get caught up in all the bullshit. How can I put it into words? I want to do good work, and find out who I am as a person. Each time out, I want to create an entirely new character. I want to be around for the next fifty years.

I feel like the majority of scripts today are written just to make money. There are some good ones out there, but it's just beginning to turn around to meet the needs of the teenagers. There are always going to be teen exploitation movies, because they make money. They're mindless movies, but sometimes in the world we live in, we need to see things like that. There's a need that is being fulfilled. I don't want to be a part of that film genre anymore. I want to do films that have some kind of meaning - that touch me when I do them, and that touch audiences when they see them.

I approach each role differently. I go over the overall flow of it, what the whole point of the movie is about, from point A to point Z. Then I chop up the script from where the transition in the middle is and break it up into acts. With that blueprint, I work on developing the character. I work with dreams and I go into my inner self. There is a good technical thing coming out of that. It's very Jungian. I do a little bit of the method. I'm trying to create my own method, I prepare for the role more in the emotional layers. What is my character going through emotionally? What's going on in a particular scene? Where is he coming from? It's your basic actor homework. I work from the inside out. Sometimes I ask myself, "Does this film really need to be done?" And, "Is there anything in here that I've gone through?" I don't try to approach films from the ego perspective that it's going to affect 200,000 teenagers across America and that I'm going to be a part of it and change the world.

I learned quickly about managers and agents. I got hooked up with a guy who ripped me off and took me down the wrong path a little bit. But I got out of it very quickly and met the right person. I've been very fortunate. When you start coming to the right place, and you make a conscious decision to that, you attract positive energy. When I changed my idea of what I wanted to do and started working hard, the right people started coming to me. Whatever you put out comes back to you multiplied. If you put out negative energy and anger, you get more anger back. If you put out love, you get love back.

At first, my biggest sacrifice for success, was not going out and being cool; that was the very first sacrifice. For

the past three years, I've stopped living to a certain extent. I've hung out at my house and I've gone to the opposite extreme of my days in New York. I don't know if that's a sacrifice any more though. Now, not being true to myself all of the time is my biggest sacrifice. We label ourselves as actors and it gets us into trouble. You can get the attitude of "I'm an actor now. I hang out, smoke cigarettes, wear a leather jacket, and talk about 'acting.'" Yes, I am an actor but, yes, I am a human being, and I have to remember that I am a human being first. I don't want to be associated with the acting. That means if I do a bad movie and I fail as an actor, I don't fail as a person, and I'm not a bad person. I'm working hard at getting that attitude.

What I like the most about success is not having to audition, and you get a little more respect and recognition. You walk down the street and people recognize you. It's like I'm back in my hometown, anywhere I go. It's weird but it's warm.

The person I would want to play most in an autobiography is Montgomery Clift. He was one of the first actors who achieved notoriety, but got so caught up in his personal struggles it destroyed him. He had deep pain. I sometimes wish I had that. I have pain in my life but I don't have it as deeply as he did. I tend to go to the opposite. What I don't have, I want, and what I have, I don't want.

Spiritual things have been important to me too. I'm starting to meditate. I'm trying to find the path that is going to work for me. I'm into Siddah Yoga and meditation and reading books on it. I'm not spiritually enlightened, but I'm trying to get there. It's hard. I have a guru, Gurumayi. She's an Indian woman from a long lineage off Siddah yogis who are spiritually enlightened beings through training themselves and strengthening their minds. It's a philosophy that says God and Greatness are within ourselves. They don't say "No" to any God. They accept all religions. You don't have to shave your head and give them all your money. It's about yourself. Dealing with yourself, and dealing with your own problems. The basic philosophy is simple. Love yourself, "Om Namah Shivaya"· I respect myself. I think the collective consciousness today is getting around to that.

If I had three wishes, the first would be to be enlightened. Wouldn't you wish for that? My second wish would be to be married to Isabella Rossellini, and my third wish would be to be at peace with myself. I could say that I wish to be a great actor. To me, passion is total commitment. Love. There are moments when you look up and suddenly everything connects. Those moments are passion. There's a new consciousness among young actors. They are a lot more aware of what's going on and being true to themselves. The passion to them, as it is to me, is in the work and that's really what its all about, isn't it? ★ PATRICK DEMPSEY, SEPTEMBER 1987

CHRISTIAN SLATER

In 1986, while living in New York City, an actor friend, Alan Boyce, told me to watch out for a talented kid named Christian Slater. After I moved to Hollywood in 1988, I would often see Christian at premieres and clubs. One time we ran into each other at Formosa Café, a landmark bar and restaurant in Hollywood, and ended up drinking shots of tequila together. Then we moved on to Mickey and Joey's, an espresso bar co-owned by Mickey Rourke. Amazingly, Mickey himself was behind the bar serving cappuccino.

On a sunny afternoon in April of 1989, I picked up Christian outside his West Los Angeles apartment building. We drove to Venice beach for the shoot, and started the interview in the car. (On the way, we stopped at a Lucky supermarket so Christian could buy some smokes. He took the tape recorder with him.) *Yep, going into Lucky. That man who honked at us pissed me off. Here I am now, walking into Lucky to buy a pack of smokes. Do you have any cigarettes here? I just want one pack. Now I'm walking out off Lucky's. Karen, where are you? Where did you park? Oh, there you are. See, now I found you.*

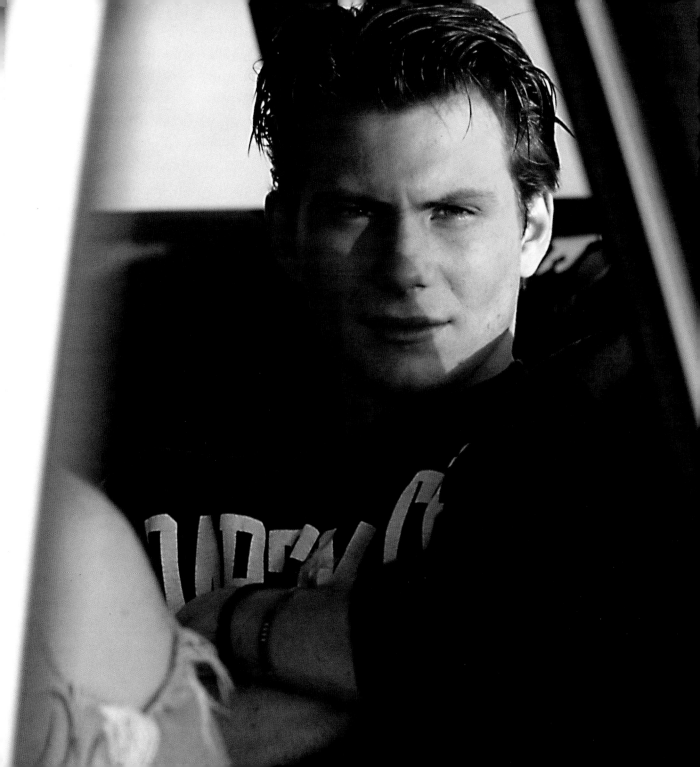

I grew up in New York City. My mother and father got divorced when I was six. I feel like I was always a step ahead of everybody because I had a mother and father who were in the business. My father was an actor and my mother is a casting director.

I hated school. There wasn't one subject that interested me. I went to this prep school called Dalton on the Upper East Side. I felt like I was being groomed to be a lawyer. I wasn't into that at all. It wasn't my scene hanging out there. I wasn't into being a preppy kid. I always knew inside that I was going to be an actor.

When I was nine years old, they wanted to hold me back a year, after I had toured with The Music Man for nine months. My mother transferred me to the Children's Professional School because they had a correspondence system set up so that I could continue to act and still keep up. I got The Music Man because Michael Kidd, the director, had seen me on a talk show with my mother, and called me in for an audition. I sang, "Zip-a-dee-doo-dah" for him and Dick Van Dyke, and they liked it. I knew what I wanted to do, but I was terrible at nine. I would wave to my mother in the audience.

> It comes naturally, I suppose.
> Acting classes to me are malarkey.
> Actors are born, not made.

Initially, my mother didn't really want me to become an actor because she knows how difficult and competitive "the business" is. She didn't want me to get hurt. I used to kid her by telling her I was going to be a lawyer, just to make her happy.

Since she was working full time, I had this cool guardian who'd go around with me to auditions. My mother ended up giving me my first TV job, five lines on a soap opera. I played a kid who fell off his skateboard and went into a clinic to get patched up.

I started to get plays off Broadway, then on Broadway. By the time we moved to LA, I had grasped the professionalism of acting. Nowadays my mother is very happy for me, she knows that I'm very serious about acting. She knows that it's what I want to do for the rest of my life.

I'm instinctual, mainly. I go over a script and whatever feels natural and comfortable, I go with it. It comes naturally, I suppose. Acting classes to me are malarkey. Actors are born, not made.

I'm just an actor. Beyond that, I don't really know who I am. I'm 19 and I'm completely confused about that. I guess I'd say I'm a nice guy who has fun at what he does and is basically playing. I guess that's how work should be. Acting was always the main thing that got me going. It's really fun for me. When I'm working, I'm most comfortable. I'm at ease with myself. I don't go out at night and I'm on a good schedule. I need to get a hobby or something because when I don't work I'm usually out playing, making a fool out of myself and enjoying it. But it's acting that really centers me.

Most of my friends are either in the music business or the film business. I sing a little. I may cut an album one day. I'm 19 years old and I'm starting to explore women right now. They are a fascinating subject to me. Very intriguing. I like to be the hero. If I were stranded on a desert island, shipwrecked and alone with a woman, we would...what? No sex? Then I would probably take command of the situation and build us a boat. And she would fall madly in love with me, and we'd get married when we got back. I've also fantasized about being James Bond.

I have a secret desire to move to Montana and get a ranch, to get away from major cities. I want to live in a one street community. I'd probably go out of my mind after a week, but it would be so nice to go relax somewhere. Get away from it all. ★ CHRISTIAN SLATER, 1989

> I need to get a hobby or something because when I don't work I'm usually out playing, making a fool out of myself and enjoying it.

JOSH BROLIN

I first heard about Josh Brolin in 1989. My friend at the time, Stephen Baldwin was filming the television series YOUNG RIDERS in Arizona with him. I was photographing and interviewing actors and Stephen thought I should talk to him. Josh and I met on a Thursday morning at Norm's, a coffee shop in Hollywood. We stepped into the street and I photographed him in his leather jacket.

Since then, Josh has starred in several successful television series and independent films. He was finally propelled into stardom in 2007 with Ridley Scott's AMERICAN GANGSTER and the Coen Brothers' Academy Award winning film NO COUNTRY FOR OLD MEN. Since we met, Josh and his first wife separated. He is now happily married to actress Diane Lane.

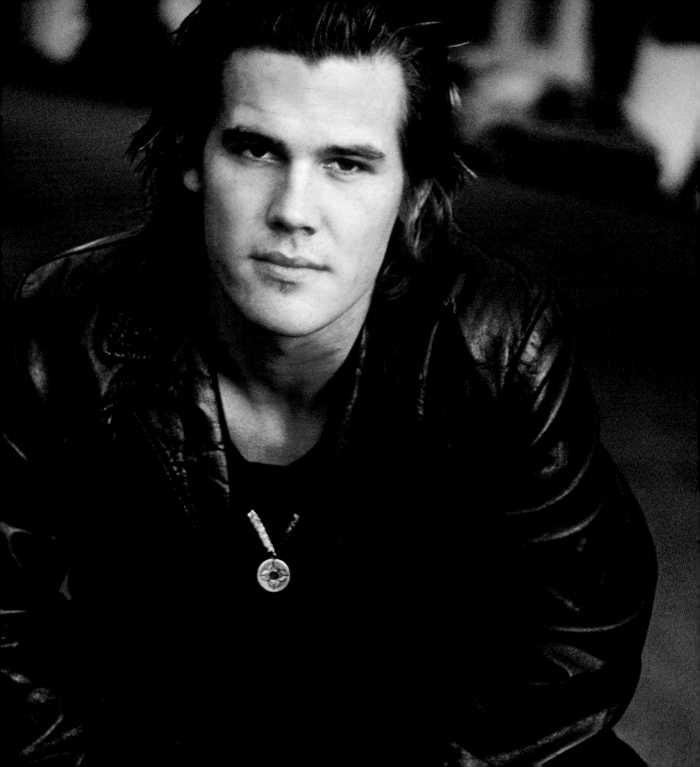

I grew up in a small town called Templeton, about four hours north of Los Angeles. Outside, all you have are acres and acres of fields of wheat and barley. As a kid, I did everything bad that you could do. I wasn't a bad boy. It was just my way of trying to find out what I was about. I think it got to a point where I couldn't do it anymore. My father was there as much as he could be. I couldn't see my father for a span of time, sometimes for 6 months, and then I would see him for three months all the time. We would always be doing things together. He'd take us with him where ever he went. He would teach us how to fish, and all the things that fathers do, but it was very condensed. It was like we were trying to fit 9 months into 3 months. In one way, it was great because I got to spend all this time with my dad when he was there. I was lucky enough to understand that when he was away, he was working for us, so we could eat.

When he was in New York for two movies, NIGHT OF THE JUGGLER and AMITYVILLE HORROR, he was there virtually the whole two years. It was '79. I remember perfectly. I went to New York for a week and stayed with him. We rode our bikes up to 100th St., at the top of the park to Harlem. We turned the corner to go back down and these guys came out of the

We turned the corner to go back down and these guys came out of the bushes and put switchblades to my neck.

bushes and put switchblades to my neck. My father turned around and... I don't know why they didn't do anything. They didn't take the bikes. They didn't take anything. My father turned around, and just gave them one of those looks. I don't know if it's because they recognized him or what, but there were six guys. They could easily have done something bad, but they just pushed my bike away. It was in the newspaper the next day. I thought, "Great! I'm in the newspaper!" That was an experience. I'll never forget that time with my father. Looking back it was that intense bond, that intense love between father and his child.

I graduated school with a 3.8 GPA. Thinking back now, I never learned anything if I wasn't interested. I could hear, I could comprehend and I could memorize it, but I realized I would never use 95% of this shit in life. My philosophy was, in school you learn how to learn, and so I kept that in mind my senior year.

I think feeling lonely is a normal adolescent thing. I dealt with it by constantly trying to find who I was. I started doing theater in Santa Barbara when I was 15. When I was 16, I did theater in LA. Acting was like a drug for me, a

total escape. I could be who ever I wanted to be and just go off with it. The first time I read for a play, I just went off with it, and my acting career started to take off.

I graduated from high school but made the decision not to go to college. I've taken classes for acting but I'm also self-taught. I read a lot. I read a lot of Russian novelists, a lot of poetry. Dostoyevsky, Gogol, Pushkin, Chekhov, Tolstoy · I could go on and on and on. Gogol is my favorite. Fascinating. About four years ago, I read "Notes from the Underground "by Dostoyevsky. It's an acting thing. Ginsberg blows my mind. You read Ginsberg's poetry about pink assholes and shit. He's gone, man. He found a place. He found a perspective that not many people can identify with. It's depressing. It's a little insane but it's me. It's so incredibly insightful.

The first movie I got cast in was THE GOONIES, written by Steven Spielberg. That was a lot of fun. Back then, Cory Feldman was just a kid. That was probably the best experience of my life, up until then. It was like working with family for six months. It was perfect. I got to do that shit and get paid. I got to just act like a kid and I got to recreate a lot of things that I had missed in my childhood. Whether the movie was good or not, I had a blast. It was also such a great experience to work with Spielberg. Donner, as a director, was such a father figure to me. Talk about idolatry, I looked up to him and said, "I'm gonna be that guy." He could have fun but at the same time, he still had the most intense concentration. He would give me advice and ask me questions. I liked it.

After that, I didn't work for a while. I switched from agent to agent. I'm sure I could have done it a lot easier and said, "Hey, Pop, what agent should I go to?" But I didn't. I had my headshots taken and I went around from agent to agent and got one. The great thing about my father was he really taught us the value of a dollar. People say to kids, "Oh, your family's rich, you're spoiled, you get whatever you want." But it wasn't like that for us. We got some stuff but I wasn't spoiled. If I wanted to make something of myself, I had to do my own thing.

Being the son of a famous actor was a challenge in Hollywood. On my third audition, the casting director said, "So, you're Jim Brolin's son." I said, "Yeah…" I was nervous as shit. I didn't know what the hell was going on. And she

> When I do a role, I bring as much of myself into it as I can, but I also try and take on characteristics of the role.

Acting gives me all of the emotions and opportunity to be what I've always wanted to be.

said, "So you wanna be an actor?" I said, "Yeah, I do." And she said, "So act." And I said, "Do you have dialogue you want me to read? Did you want me to bring in a monologue? I'm not sure. I wasn't told…" And she said, "Thank you very much, thanks for coming in." She turned the chair around, picked up the phone and started calling somebody. I thought this is how Hollywood is. I was so naïve. Now I can see that she was on a power trip. There're always good people too. I've met and been surrounded by a lot of great people. All the people who work around me are the most honest, down to earth people you'll ever meet. I can't deal with anything else. I can deal with it on a certain level for a certain amount of time but I can't deal with it beyond that.

Acting gives me the chance to explore different aspects of life. I can't get enough of life. Now I'm trying to get into it in a way that's not so self-destructive. Life fascinates the shit out off me. That's why I don't knock anything. Acting gives me all of the emotions and opportunity to be what I've always wanted to be. I can just scream out all the emotions that were repressed through my life, or I can cry out, or I can laugh hysterically and really believe that I'm doing it. Really believe it's happening. It's not fake, I mean, sometimes its fake but that's not acting. Working in TV and movies is a lot different to me then when I get on stage. When I first did a stage play in school it was the most euphoric thing I had ever done in my life. Better than any drug I had ever taken.

I'm 21 now and I'm responsible. I have a kid and I have a wife. I'm a very good father. I'm a good husband. I don't think many people could pull off what I've pulled off and be as sane, or insane, as I am, and still be able to admit that I haven't found out who I am. I'm going to continue that journey. I'm not in any hurry. It can be a positive journey. ★ JOSH BROLIN, JULY 1989

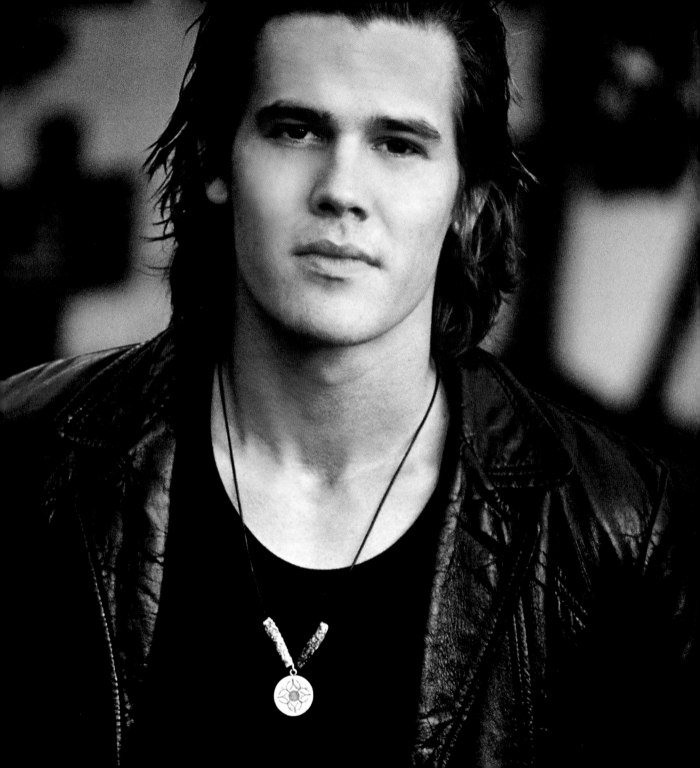

LAURA DERN

Who can forget Laura Dern's extreme facial contortions in David Lynch's BLUE VELVET? Before that, I had seen her performance as a vulnerable teenager victimized by an evil man in SMOOTH TALK. Her portrayal rang frighteningly true for me and I knew that Laura possessed the unique qualities needed to become a star. Much later, I discovered that she was the daughter of accomplished actors Diane Ladd and Bruce Dern.

In person, Laura struck me as earthy, feminine, spiritual and a good sport. She didn't blink an eye when I asked her to hike up a hill so we could do our photo shoot against the mud cliffs above the Hollywood reservoir. Laura's impressive Hollywood career has spanned twenty years. She has fearlessly thrown herself into a wide variety of roles, which are sometimes unflattering, an excellent example being her unflinchingly comic portrayal of an intensely annoying loser whose pregnancy becomes a social and political football in (1996) CITIZEN RUTH. As a result, Dern is one of the most interesting actors working in Hollywood today though she is most well known for her role as Dr. Ellie Sattler in the JURASSIC PARK franchise. Her love life has also kept her in the news. Over the years, she has dated actors Kyle MacLachlan, Jeff Goldblum, Billy Bob Thornton and director Renny Harlin. Currently, she is happily married to musician Ben Harper with whom she has two children.

Recently, I ran into Laura on a nearby street in LA. We were both involved in chasing down a panicked brown lab running down the street. Together we were able to catch him and return him to his home. I found Laura to be as lovely and down to earth as ever.

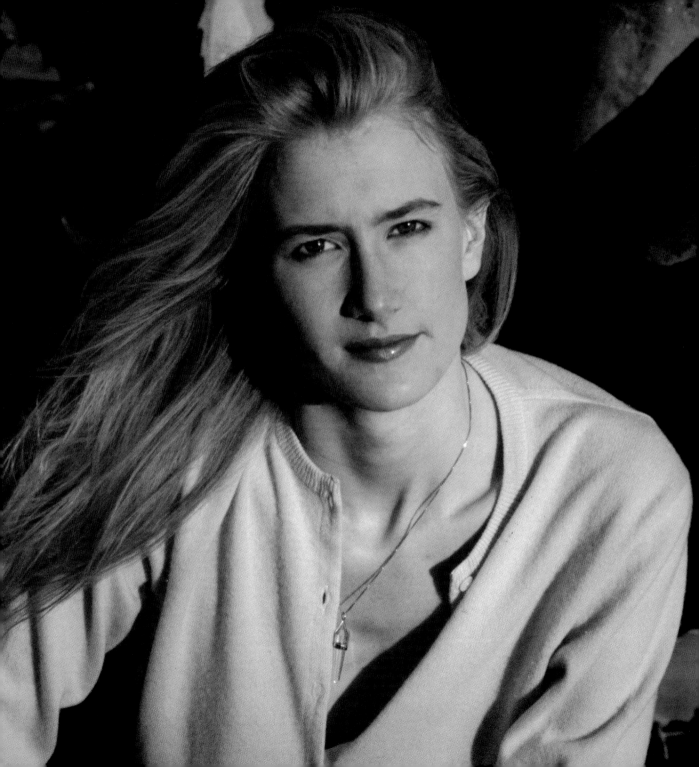

(LARA DERN)

I grew up in Los Angeles, in a suburb near Coldwater Canyon. It had a middle class feel to it. Ours was an all female house: my mother, my grandmother and me. My room was my place, my solace. I was a creative child, confused but always searching.

When I was nine, I decided to become an actress. I had done a little extra work and after Martin Scorsese complimented me on being able to sustain 20 takes of licking an ice cream cone (in ALICE DOESN'T LIVE HERE ANYMORE), I was hooked. My parents conveyed to me the hardships of acting, but their understanding of their craft, combined with their passion for it was so beautiful it overshadowed the struggle. When I told my mom I wanted to become an actress, she said, "If you want to do it, you're going to have to do it on your own, and you've got to study for at least two years before you start auditioning." So I went to the Lee Strasberg Institute.

> ## Suddenly you find yourself acting because you want attention, to be in the limelight and to be worthy.

When I was 11, I met an agent at the house of a family friend. I told her that my parents wouldn't help me, but that I really wanted to be an actress. She told me to come into her office and do a monologue for her. Afterward, she sent me out for this movie called FOXES. I lied and told the casting director that I was 14, but I could play 17. I screen tested for the director who thought I looked too young, but he liked me and gave me two scenes in the movie. That was my first job and from then on I dedicated myself to my career.

During high school I was very busy with acting, school and participating in student government. I was very political and very liberal. One could have an argument with me. I was kind of independent. I was an actress.

As a teenager, producers and directors and casting directors would tell me, "We don't want you, we want her because she's prettier," or "She looks more right for the part," or "She's a better actress." Insecurities creep in. Egos creep in. You can really get trapped into that. Suddenly you find yourself acting because you want attention, to be in the limelight and to be worthy. You want to be accepted. It's easy to get trapped, I had to fight that. There have been lots of times when somebody has said, "Sure, I'd love to meet Bruce Dern's daughter." That may get me in the door, but it never gets me the part, ever.

Most scripts are the worst. So many people get caught up in what's marketable. How are you going to know what's saleable unless you try it? If it's different, how are you going to know if it's going to work or not unless people see it? The studios buy what's been proven, whether it's Sly Stallone or whatever the fad is at the moment. I get sick of seeing trends in scripts. I love seeing people doing things that are different, just simple stories, just truth. I look for truth. When I start hearing characters say words that are not believable, then how could I say them? I really care about the state of the world right now and I look at scripts that will make a difference, even if it's a small one. I felt the film SMOOTH TALK was important. No one had ever looked at a young girl's sexuality on film like that before. I had to think for a long time whether or not to do BLUE VELVET. Ultimately, my trust in David Lynch won out. His vision is fantastic. When I first read the script, I really wanted Sandy to have some strength so that the audience could see the light in the darkness.

The more I work, the more excited I get about all the things I can learn. The more you learn about yourself through studying, the more pure you become, and the more pure you can be on screen. To me, learning about yourself and learning about acting is the same thing. Working on sensory things, knowing how to recall textures, being able to go back to how you felt, all make your performance more honest. When making a film, there is so much make-believe around you, it's hard to be honest all of the time.

My biggest sacrifice has been college. Sometimes I just want to be a person having fun, going crazy with midterms. I feel guilty about not going to college. I went to UCLA for two days before I got SMOOTH TALK and USC for two months before I got BLUE VELVET.

I love to read and paint and go horseback riding and there's no time to do those things right now. Eventually, I'll want a family and children and coordinating that with my career will be a struggle. I also want to be involved with the future of the world. I'm really scared about our future.

What spiritual things are important to me? Learning to come from a place of love. Learning to be satisfied with myself, feel worthy and, in my acceptance, being able to share that with other people. That's a major battle. I need to become grounded in a sense of myself where it's quiet and at peace.

> To me, learning about yourself and learning about acting is the same thing.

I would love to star in an on screen biography of Monet, but I'm not an old man. He just enjoyed the simplicity of life so much. I'd love to play someone who's constantly discovering life through simplicity.

If I could remake any movie, I'd probably choose STAGE DOOR. I'd love to do any of the parts in that film. The beauty of that movie was that actresses like Katherine Hepburn, Ann Miller and Lucille Ball were all in it before they were famous. I love Katherine Hepburn. She's perfect. During that period, actresses had the opportunity to show different sides of themselves. Today, leading ladies have to do more with fewer films.

My ideal leading man? I got my wish once, Kyle MacLachlan. Kyle reminds me of Cary Grant. I want to work with every one who's great. I'd also like to work with my parents.

Why should a director choose me? Because I would commit. I could guarantee 100% commitment. Whereas some actresses are not ready to do that.

I feel I am the kind of actress who can enjoy acting without falling victim to the business. Politically and socially, the world is now a new place because of everything from AIDS to nuclear arms to teenagers being stars of movies.

Maybe my generation of actors can be a more conscious one. That would be really nice and an honor to be a part of.

★ LAURA DERN, DECEMBER 1987

·Politically and socially, the world is now a new place because of everything from AIDS to nuclear arms to teenagers being stars of movies.

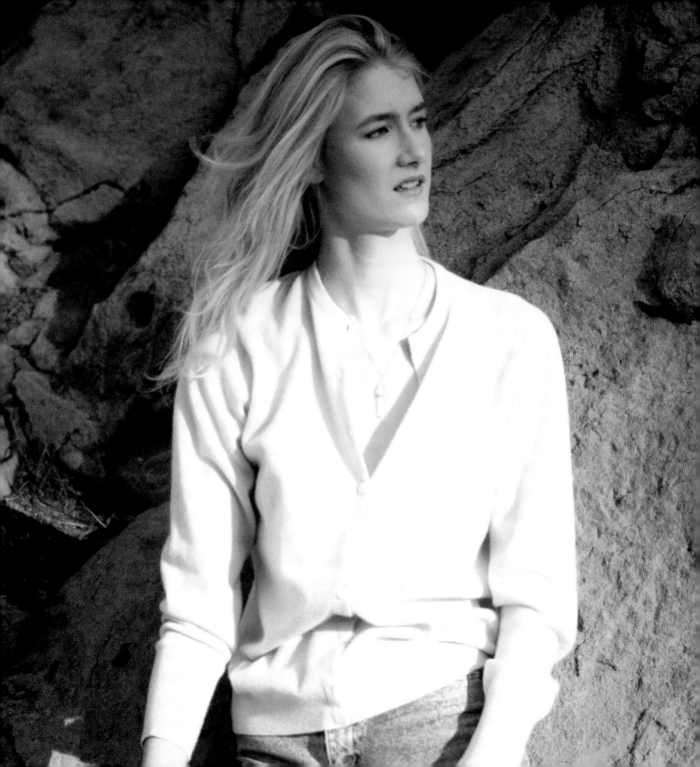

JOHN CUSACK

I backed into another car twenty minutes before meeting John Cusack. I had recently moved to Los Angeles from New York and had little experience behind the wheel. When I arrived at the Mondrian Hotel for our shoot, I was still shaken up. To console me, John bought me a beer and explained that the bandana he was wearing was due to the fact that he had gotten drunk the previous night and shaven his head on a whim. We joked about our respective misfortunes. During our discussion, I found John to be articulate, worldly, and a true gentleman.

An interesting and talented actor, John Cusack's commitment to his craft is a rarity in Hollywood. Since his starring role as the charming heartthrob in SAY ANYTHING, Cusack has gone on to star in such noteworthy films as HIGH FIDELITY and BEING JOHN MALKOVICH. His most recent project, WAR, INC., once again, exemplifies his confidence and commitment to his work. As a writer, producer, and star of the film, he plays a contract killer who finds himself in the fictitious, war torn country of Turaqistan, which is the object of a hostile takeover by an American corporation. With this film, John Cusack continues to entertain and educate us with his unconventional, unique perspective.

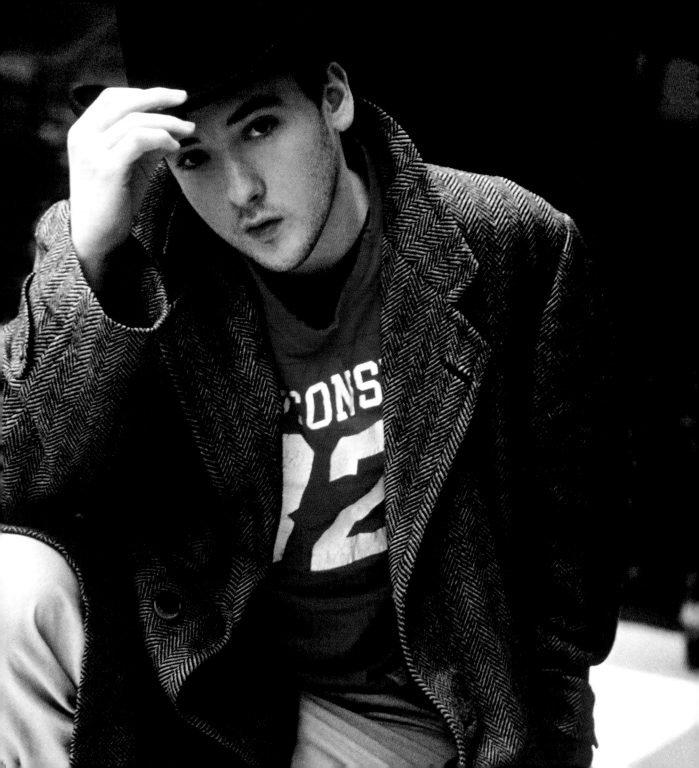

They're not like regular people who are happy being themselves and happy with ordinary pleasures. They have a much deeper want.

I grew up in an upper- middle- class home in one of the finest suburbs of Chicago. My parents weren't unbelievably rich, but they had enough money when they started out to buy a house in that nice area. They went through periods when they would scrape for the money to keep it, but we were rich enough to have a college education if we wanted it.

My mother would describe me as somewhat of a problem child. I was very anti-establishment and discontented a lot of the time. I was a very imaginative child. High School? I didn't get along with that institution. I was very anti high school. I hated high school with a passion. I cut school as much as I could to remain a B+/C- student. My parents would have raised hell if I didn't at least get decent grades.

I started out going to public school but my parents were concerned about me and sent me to catholic school. In sixth grade I created an alternative language. It was called "Jo Mania". It was kind of an anarchy gibberish code that me and a couple of other sick little monsters thought up; a series of non-sequitur abstract paragraphs that we would spew at people. We thought it was the funniest thing. We'd call up radio shows till five or six in the morning on school nights. We would talk about Ed Asner eating corn and play it back. We'd laugh ourselves into crying fits. The more absurd the better. So I spent most of my time spewing gibberish as a child. I was only interested in doing things that interested me, as I still am. I've never had the discipline to do things other people's way.

When did I decide to become an actor? I think people fall into it because that's what they are. People I know who are good at it are social-psychological mutants in a way. They're either shy, introverted people, or they have a great need to express themselves so they don't explode. They're not like regular people who are happy being themselves and happy with ordinary pleasures. They have a much deeper want.

I was doing theater when I was very young. My parents were hip in that way. They exposed us a lot to the arts and culture. When I was 10, I got into a theater group called the Pivot Theater Workshop. We did a lot of different Greek tales and improvisations. Through my teens, we were adapting Singer, Salinger, and Bradbury. We'd take short

stories and put it in a form where you'd speak out to the audience. It was good training.

I wonder sometimes, why I had this drive at the age of 13 to be in films and why I wasn't content to go and play. I got my first role in an industrial film when I was 14. I went and shot it and got 700 bucks. I did one where a city boy goes to the country and discovers the wonders of dairy products. He meets his cousin Tracy

I first started out doing roles in films probably motivated by a little jealousy of other people and wanting attention, combined with ambition and drive.

and his Uncle Jim, and they talk about dairy products. It just doesn't seem right to me now; that I was doing that, but, um, you know, so be it. Then I did some commercials. I did one for nightlight. My lines were, "Look, flick this switch, it's a flashlight. Flick this switch, it's a wild strobe." Now you tell me who I was ... some weird fucker. It's equally strange to see eight year olds with glossy eight by tens. I think it's kind of a sick thing.

I first started out doing roles in films probably motivated by a little jealousy of other people and wanting attention, combined with ambition and drive. I really did think that I could do it. When I was eight I had this weird pragmatism that "no, I couldn't be a football player but I could be an actor." I thought, "Yeah, I can do that. Sure, I can bullshit." That's what I thought it was, in a way. The people who I hooked up with taught me respect for it (acting). Then, when I was 16, I walked into my agent's office, Ann Geddes in Chicago, and I said to her, "If you get me an audition, I'll get the part." I was just a real cocky 16 year old. The next day she sent me out for CLASS and I got the part.

My goal today, is to do no more bad films. One of the things that got me in trouble in the beginning is that I improvised a lot in theater and I thought I could fix holes in scripts by improvising cool lines and coming up with stuff. What I learned is that the holes don't fix themselves. It's in the play or in the script. So you have to look for a good script first. Then, of course, you want to work with great directors like Alan Parker, Stanley Kubrick, or Woody Allen.

What kind of roles am I looking for? I don't want to do anymore love stories where I fall in love with a girl, because I

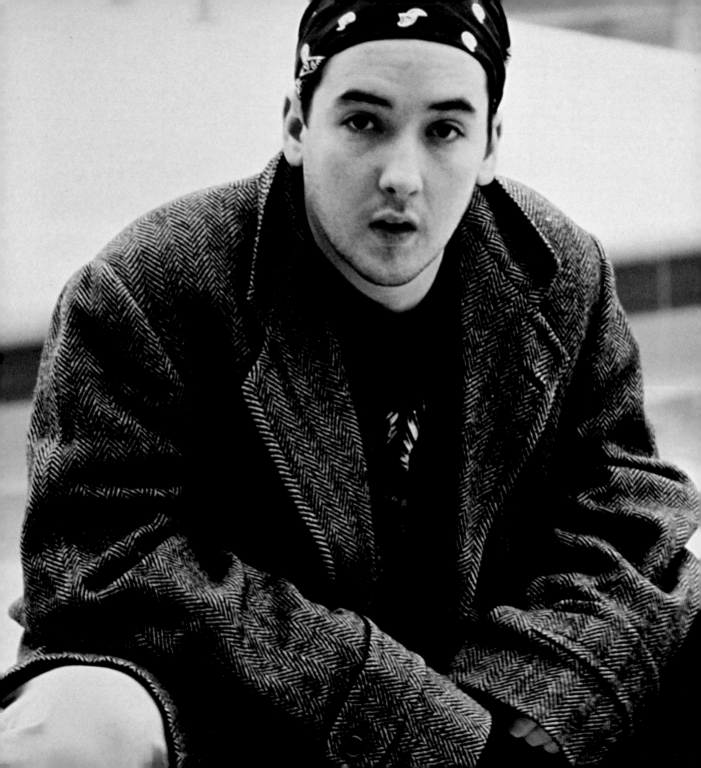

feel like I keep doing that and I keep graduating from high school. That's kind of my dream and my nightmare. Then I read a script that was really well written and I say, "Fuck, man, I don't care. I'll do anything as long as it's good." Most important to me is being in a good director's film, to be a part of a good vision. I'd fucking foam for him. Just work as hard as I can.

Everything is going the way it should, I have a better understanding now of what's good. Over the last two years, I've learned a lot about the business since I did THE SURE THING. You have all these people coming at you, from all these different angles. Slimy fucks. Agents and producers who are really good at meeting in the office, who talk a lot of good game and then don't produce. I've done some of these films and made a lot of money, and been really depressed after they come out.

I have a lot of really good friends in LA, but I don't want to live here. I like snow. I like wearing a nice overcoat. I like the look. I like roaring fires around Christmas time. I like to be with family and friends who I grew up with. LA is not really seasonal to me. In LA, you go out and you only meet actresses; people with scripts and stuff. I guess LA is the capital of the film business so that's normal. But I've done three films and a play here. So it's not as if I don't ever go to LA.

When I do a role, I bring as much of myself into it as I can, but I also try and take on characteristics of the role.

Acting for me is instinctual. I just try to put myself there and start imagining. I spend time thinking about it. I think studying things other than acting is important to my growth as an actor. At NYU, I took a law class and an ethics class. I feel that the more I grow as a person, that the more I learn about cool things, meet cool people with good visions and ideas - the cooler I'll be on film and on stage.

What do I look for in a script? I think that it's either got to be funny, or it's got to make people think. So far, all I've done in my career is make people laugh a couple off times. Or maybe made them think. Probably not, probably just made them laugh. But I will. I'll try to do all those things in the next years.

The only weird thing, even at the modest level of my success, is when people you don't know come up to you and want to be a part of your life. You try to be courteous and stuff. It's strange because, by them actually seeing you, it

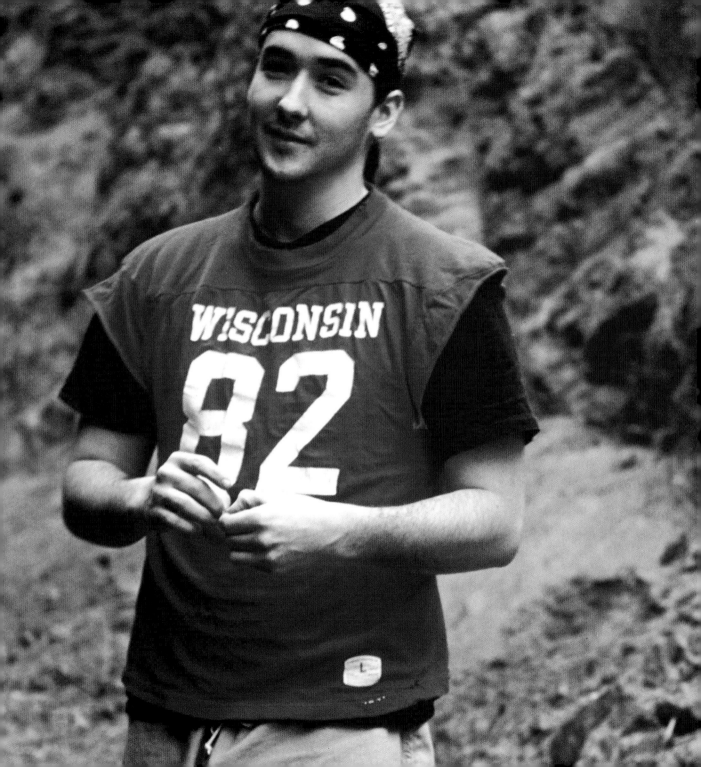

makes them feel better. It's a weird kind of responsibility. But you know, at times it gets tiring. I'm trying to do some theater in Chicago and see my family, and find another girlfriend - and these people just want to talk to you about your films and what you've been doing.

There was a lot of me in THE SURE THING. When I do a role, I bring as much of myself into it as I can, but I also try and take on characteristics of the role. In TAPEHEADS, I got a chance to do something I hadn't done. I got to play this sleazy, white trash would - be video producer. And when I was doing that film man, I was talking like that. I started taking on a lot of the characteristics of that character. You spend two months talking, discussing and thinking about this character in film, and, before you know it, you walk off the set and you've got your pencil-thin mustache and long hair. You find yourself talking to women in clubs and saying these ridiculous things.

After you finish a film it's strange. You go out 10, 12 weeks, and you're just going boom boom boom, hauling ass. Trying to make all this stuff work. Then you finish it, and you look around

After it's over, you just go out and drink beer and stare for a couple of days.

and there's nothing to do. Your regular life can't possibly be as exciting as those 12 manic weeks you spent with that new group of people. It's like you become a family and you have affairs and you do all these things on the set. After it's over, you just go out and drink beer and stare for a couple of days. There is a kind of let down that way. When making a film, there's a fine line between being in the spirit of partying with your fellow actors and your commitment to your work. That's a struggle. Fuck man, I'm 21. I'll work it out.

I've never had an image of myself being like James Dean and Marlon Brando. I relate more to actors like Dustin Hoffman and Jimmy Stewart, who were never into being unbelievably introverted superstars.

My biggest fear is that I'll waste my potential. I'm just starting off my career and I don't think what I've done has been all that impressive. If you recognize that I'm a good actor, hard working and trying to do better projects, then that's all I ask for. All I can say is that I will do a lot of good work in the next ten years, because that's what I want to do. ★ JOHN CUSACK, JANUARY 1988

up her face.

She is very grounded and real, crediting her spirituality to her Dutch mother who now teaches Yoga in Vancouver. After PARTY OF FIVE she went on to star in the box office smash SCREAM and it's sequels, along with THE CRAFT and WILD THINGS opposite Denise Richards.

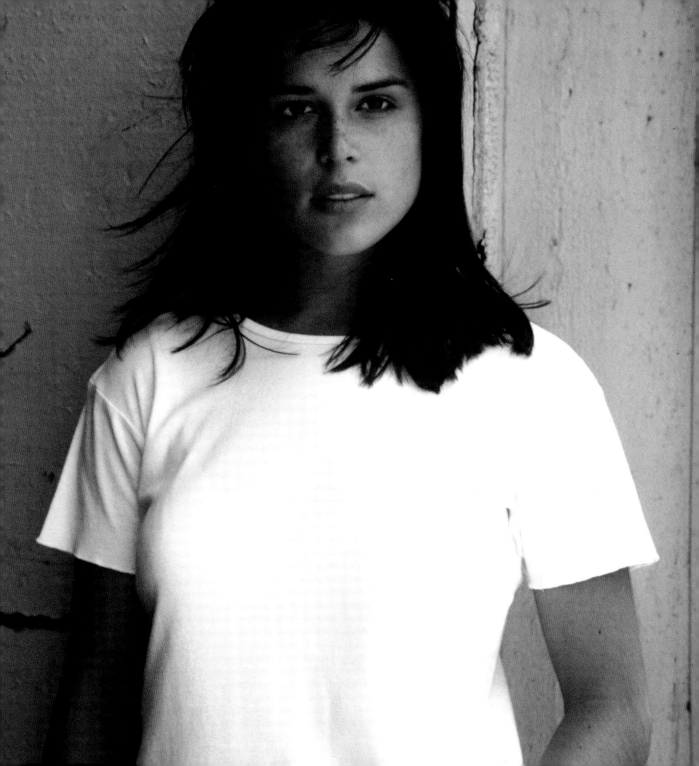

I'm from Toronto but I was born in a town called Guelf, which is about an hour outside of Toronto. My parents divorced when I was a baby. I lived with my mother until I was four and then I lived with my father, Jerry Campbell in Mississauga until I was eight. I would spend every other weekend with my mother in Guelf. I moved to Toronto with my dad when I was nine, the reason for that being that I was accepted to the National Ballet School of Canada in Toronto. My father was very enthusiastic about the fact that I'd gotten in, so we moved to Toronto and lived there. I started dancing when I was six years old. I saw THE NUTCRACKER Ballet and fell in love with it and wanted to be a ballerina and by the time I was nine did THE NUTCRACKER at the O'Keefe Center with the National Ballet of Canada. I've been dancing ever since. It's only in the last years since I've been working so much in film that I haven't

It was always in my heart to be a dancer and I'm lucky because I was, for a while.

really continued my dancing, but dance is by far my biggest passion. It was always in my heart to be a dancer and I'm lucky because I was, for a while. I've got hip problems so I had to quit, but I did do PHANTOM OF THE OPERA when I was fifteen for two years and did classical ballet. So I had the opportunity and I'm glad I had that. I'll probably choreograph again at some point. I have a bid on a house right now that I'm so enthusiastic and excited about. I really hope I get it because all I really want is to have a dance space and there are fourteen hundred square feet downstairs that I can turn into a dance studio. Then I'll be really happy.

I take classes when I can, but it's been difficult with the show (PARTY OF FIVE). For the first two years we were doing a lot of publicity to get the ratings up, which meant we had to travel to different states on the weekends to do mall signatures, so there wasn't much opportunity to take dance lessons.

My father and mother met while doing a play at the University of Windsor. They both had the aspiration to be actors. They got married and had my older brother, Christian and I at an early age and didn't continue the acting. But my father has been teaching drama in high school for the last twenty-five years and throughout my childhood directed an amateur theater group - a Scottish group, because my father is originally from Glasgow. My brother and I were always in the plays. We had a blast doing pantomime and theater. My mother owned a diner theater. I'd sit in the back of the diner theater a lot and watch the plays and watch people's reactions.

While I was doing PHANTOM OF THE OPERA, an agent picked me out from the audience. They wanted me to model,

so I started modeling and absolutely hated it. I think a big part of that is that I'd trained since I was six years old and standing in front of a camera doing nothing didn't intrigue me that much. I took on a commercial agent and did about ten commercials during a period of five months. I did a Tampax and Coke with Brian Adams. A month after I left PHANTOM, I booked a TV series called CATWALK which I did for a year. I left because of a dispute with the producers. Six months later I moved to Los Angeles. I'd known I needed to come, because you get to a certain point in Canada, unfortunately, where you can only get so far and then you have to move to the States to get big. Canadians don't really acknowledge their stars until they get big in the States, which I think really need to change. I knew I had to go. Producers on this movie of the week that I'd done for NBC suggested that I fly to LA to meet the network. I flew out a week after the big earthquake so none of the agents were really willing to see me because they were picking up their houses. It was difficult, but a week after that I met a manager, Arlene Forester, who said she would help me out and get me a few auditions while I was looking for an agent. Within a week I had an audition for PARTY OF FIVE and got it.

All throughout school I was the loser of my class. I had absolutely no friends. I had a really difficult time relating to people my age. I always felt I related better to people older than me, maybe because of my family circumstances. I was able to bring those insecurities to my character, Julia, on PARTY OF FIVE. I think it's important to have a character on television that doesn't have it all together, that girls can relate to.

If my best friend were to describe me, he'd say I was intuitive, street-wise, very giving and sometimes too trusting. I believe that everyone should have faith in themselves and faith in the diamond that they have within themselves. It's about strength and believing in energy and believing that what ever you put out will come back to you and whatever you ask for can come to you if you ask for it nicely and if you're positive. It's about growth and everything in life being a learning experience, whether it is negative or positive and therefore it becomes positive.

In terms of the future I definitely want to move into feature films as a solitary thing. I love doing television and I love doing a series but I'm at a point now where I'd like to be doing other characters. Also you can do three months on a feature and then you can take as much time off as you want and have time for your friends and for your life. Right now I'm working fourteen hours a day, every day and doing a lot of publicity on Saturdays and Sundays. I definitely want to get to a point where I don't need to be working that much and I can enjoy my life as well.

I just finished a film, which I did on my hiatus called SCREAM with Drew Barrymore and Courteney Cox. I was the lead in it and it was a wonderful experience. ★ NEVE CAMPBELL, JULY 1996

DAVID DUCHOVNY

In the summer of 1992, I met David Duchovny at a beach party in Malibu given by publicist Jimmy Dobson. Jimmy told me that David was a really talented actor and lent me a tape of David's movie, JULIA HAS TWO LOVERS. I found David's performance both magnetic and refreshingly original and asked him if he would do a shoot and interview with me.

We met at his older brother Danny's house in Malibu. David decided to put on one of Danny's wetsuits for the shoot. While we were talking, playfully, David wrapped my dog Oslo's leash around his neck. Afterwards, we walked down the beach to take the photographs.

Several weeks later, I ran into David at a premiere for Brad Pitt's movie JOHNNY SUEDE and later at a private screening of KALIFORNIA, which co-starred David and Brad. The only people in attendance were David, Brad, their agents, the director, Dominic Sena, Jimmy Dobson and me.

A year later, David was cast as FBI agent Fox Mulder in THE X-FILES, which instantly became a worldwide phenomenon and ran for nine years. He went on to produce and star in the series CALIFORNICATION and has reprised his role of Fox Mulder for the movie THE X-FILES: I WANT TO BELIEVE.

On a personal note, David has found happiness with actress Tea Leoni, with whom he has two children.

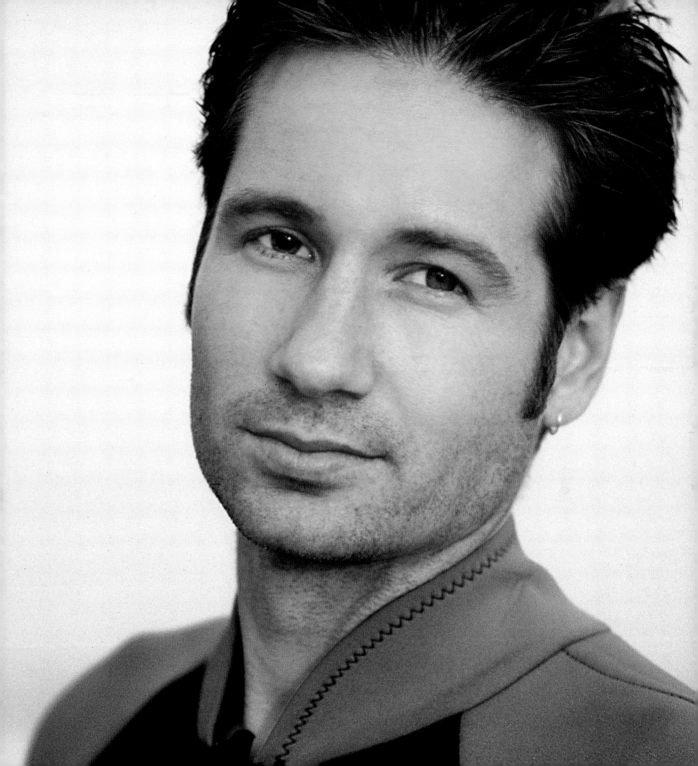

I am from the Lower East Side of New York City. We lived on 11th street and Second Avenue. It's a cross between a Ukrainian and a Puerto Rican neighborhood. I went to both public and private schools, so I had a street education and kind of a preppy education at the same time, although as I went into higher education I became more preppy. I went to the Collegiate High School for boys, which was a really fancy school right in the middle of Manhattan. Everybody had tons of money. I was the Lower East Side contingent on a scholarship. A lot was made of being smart in my family because my parents were lower middle class. They put a lot of emphasis on getting ahead through education and it was very important to my mother that I get a college degree and that I was a good student, which I was. From ages five to twenty, I'd always list that I wanted to be a lawyer or a doctor on all those tests they give you. What I really wanted was to be a basketball player. I played a lot of basketball but my hands never grew. I'm only six

I was just afraid to fail. I really didn't know what I wanted or what moved me beyond basketball or sex.

feet tall and I can't jump well but I'm a good shooter. My father always used to joke with me because he knew I wanted to be a pro ball player. He'd always tell me I had small hands. I'd come out in the morning when I was eight or nine years old and tell him if he watched closely he'd see my hands growing. All I ever wanted was to play ball. I don't know why but that's how I felt.

I went to Princeton College, which is about as preppy as you can get. I guess I had a hell of a lot of discipline and a lot of fear and that combination made me a really good student. I could study eight or nine hours a day, get straight A's and still be on the basketball team. But nothing penetrated me. I was just afraid to fail. I really didn't know what I wanted or what moved me beyond basketball or sex. Those were two things that were very black and white to me, that made me feel something in the moment. I had a high school girlfriend and I had a girlfriend in college who I stayed with for five years. I'm not saying my experience with sex was more mystical than anyone else's. I'm just saying it was an area where I felt alive.

I was kind of drifting along, which might seem like a weird thing to say because I was doing seemingly well. I was talented in a bleak way and I was just scared shitless that I wasn't going to be the best at what I was doing. I didn't know what I wanted to do. I just wanted to be the best. That's kind of sick when I think about it. I guess I just

wanted to be loved and I thought the only way to be loved was to be perfect or some kind of golden boy. After college, I took a year off and bartended in New York City. I applied for scholarships thinking that if I continued to be a student

> In acting, I felt like I was playing ball again. Acting brought me to the surface.

I could somehow put off defining myself. I continued to be a student. I worked well within that system. I got the scholarship at Yale and they actually paid me to go there. They paid graduates who were interested in becoming professors with the hope that they would teach at Yale. So now I feel guilty because I took their money and I'm not a professor. I have an ADB, which means "All But Dissertation". My mother still hopes that one day I'll finish my Ph.D., but I don't think so.

Yale is famous for its drama school. I started hanging out with the people there. I started writing a play and in order to learn more about writing I took an acting class. In acting, I felt like I was playing ball again. Acting brought me to the surface. I felt the education I had was cerebral and academic and that I hadn't educated the part of me that gets angry or cried a lot. I hadn't really educated my heart. I had a brain the size of a house and a heart the size of a pea, so I decided I had to even that out a little. I think people are instinctually drawn to areas that will teach them something. It was to learn this lesson that I didn't learn until now. There's nothing wasted. I think the better part of me, was drawn, to a discipline, where I could feel rather than think.

Before I thought of acting professionally, I had no fear because I was a teacher and a writer already and I thought, why don't I try this? I auditioned for anything · commercials, soaps, TV, movies. My first acting job was a Löwenbrau commercial. I was petrified. I sucked. I remember I was so tight that the cameraman and the director put tape over their noses to make me laugh. That made me tighter because I thought, "Oh my god I'm so bad they are treating me like an infant". I was on screen for a few seconds and they actually paid me money. I remember going home and thinking, "You stink, you'll never do this, you're too uptight".

I came out to LA because I wasn't getting anywhere in New York. That initial fearlessness that I had because I hadn't committed to life left me immediately. All of a sudden every audition became important. I had to learn how to be a professional.

I first moved to West LA and then I got a rent controlled sublet in Santa Monica. I wrote a lot of poetry. I went through periods of rejections, getting close on things but not getting them, having no money, leeching off friends and losing lovers because they thought I was a no-good bum. That was in 1988. Eventually I got better and things turned around. I did a movie called JULIA HAS TWO LOVERS. We did it in a week and it cost $25,000 to make. I never thought anything would come out of it. When it got worldwide distribution it gave me some confidence, like maybe I could do this. Then I got a small part in DON'T TELL MOM THE BABYSITTER'S DEAD, which allowed me to pay bills for a little while. It was just a matter of keeping my head above water until I could start moving. THE RAPTURE and a part in TWIN PEAKS soon followed. It has been a steady incline, which I'm

During my first few jobs, I thought, let me get through this experience without embarrassing myself. Let me not fail.

happy with. I feel a little more confident since I know what I'm doing now. During my first few jobs, I thought, let me get through this experience without embarrassing myself. Let me not fail. As I got more comfortable, my goals changed to · "Let me do something interesting, let me create something of importance, let me do something positive".

When you die, you don't want to say about yourself, "Well I maintained a certain level of adequacy over a certain number of years". Of course, the danger is, when you aspire you can also fall. What are my dreams now? I think everybody has something to express in their lives. I want to find the thing I'm great at.

I think it is possible to value yourself enough to say, "I am unique. There's never been anybody like me. Therefore, it is my duty on this earth to manifest that self in a unique way." I'm not infallible and I think you can live your life developing yourself, while spiritually you also realize that your self is the biggest piece of shit. It's a joke, it's a cartoon, it doesn't exist. But the fact that it's a cartoon doesn't make it any less loveable or any less beautiful. In fact, it gives it a kind of sadness. Where do I see myself 10 years from now? I don't know. Ten years ago I never would have imaged myself sitting here now. ★ DAVID DUCHOVNY, SEPTEMBER 1992.

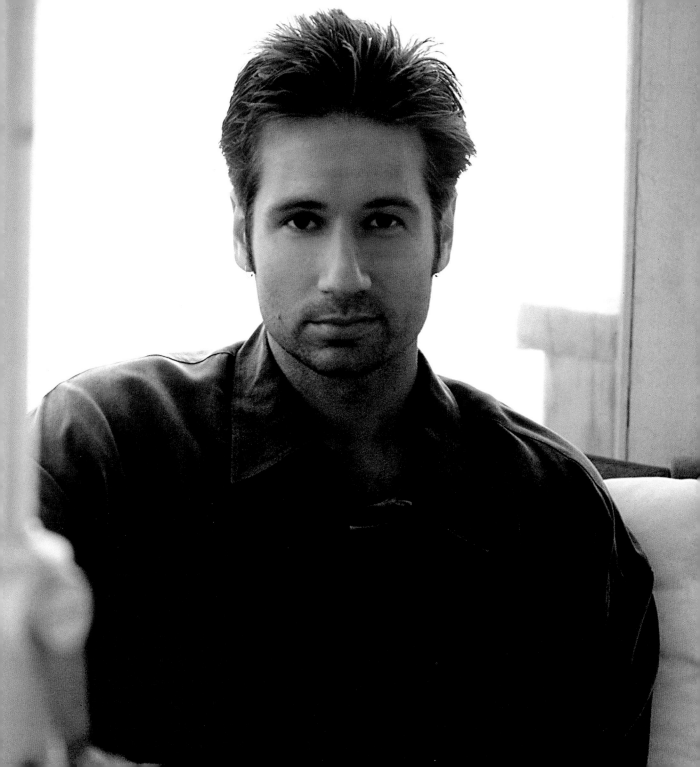

STEPHEN BALDWIN

In the fall of 1986, I met Stephen Baldwin coming out of a tanning salon in the West Village in New York City. I had already heard about Stephen from Chris, an employee of the salon who was aware that I was searching for actors to photograph. Stephen and I became friends. Coincidentally, at around the same time, I met Billy Baldwin (Stephen's brother) and Julia Roberts at my girlfriend Gianna's place on the upper West Side. Billy had just returned from a modeling stint in Milan with Gianna's boyfriend who was also a model. Julia and Gianna shared the same manager, but Julia had not yet done MYSTIC PIZZA. Eventually Billy and Julia would briefly date.

Stephen would come to my place and perform scenes from his auditions for me. When he acted, there was intensity in his eyes that seemed to set a spark in his being. He was amazingly talented and in a way, a little lost. Acting seemed to center him. Stephen, Billy, his manager Pat Reeves and I were all thrilled when Stephen got his first job, a scholastic after school special about an all boys' school. Soon after, he booked THE BEAST co-starring Jason Patric. After I moved to Los Angeles, Stephen would stay with me when he had meetings in town, and I accompanied him to several social functions where we ran into other young actors, like Sean Penn. It was not long before Stephen's career took off and production companies put him up at hotels like the Sunset Marquis and the Mondrian in Hollywood.

Recently, I ran into Stephen at Urth Café, a trendy Melrose hangout. Over the years, religion has taken a major role in his life and provided him with the spiritual fulfillment he was searching for. Most recently, Stephen appeared on Donald Trump's CELEBRITY APPRENTICE.

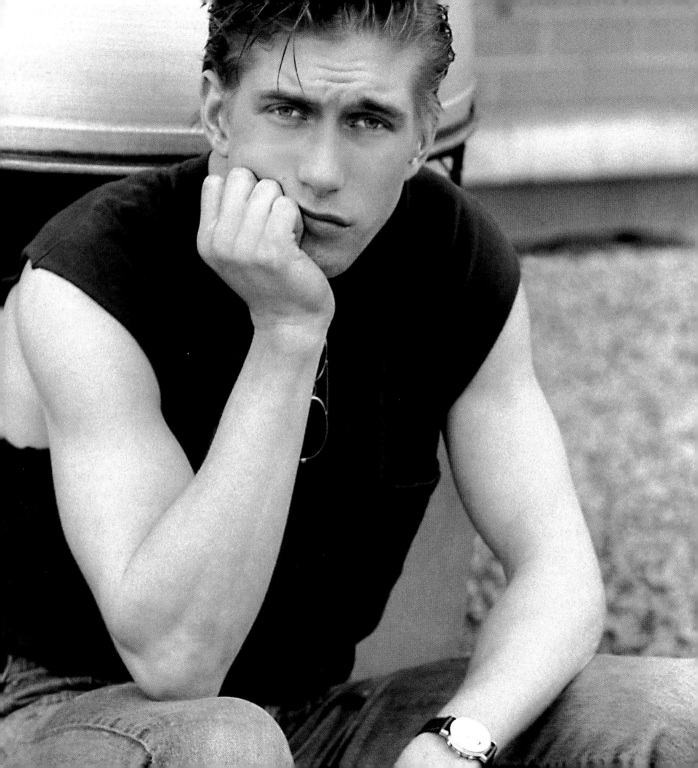

"

I have three brothers, Alec, Daniel and Billy. I'm the youngest. We grew up in Massapequa, Long Island, outside New York City. Whenever my brothers would get mad at me, I would run under my mother's skirt for protection. She would always stand up for me; I was her baby. My father was a social studies teacher. He taught high school for thirty years. He was a great man, a selfless, compassionate man whose life was dedicated to teaching and being there for all his students. I didn't fully appreciate his greatness until after his death; he instilled in my brothers and me a sense of responsibility to society. If I were to ever create a film project, I would like to base it on my father's life.

As a kid, I was a little terror. However I was also able to charm and I loved to entertain. In high school, I was a cut up and the ham, but I knew how to pull the wool over peoples' eyes and get away with murder. I'd have my friends stand guard while I was behind the

> In high school, I was a cut up and the ham, but I knew how to pull the wool over peoples' eyes and get away with murder.

wall kissing some girl I wasn't supposed to and I'd generally try to get away with as much insanity as I could. I was in high school when I first started acting and I found the more I pursued it, the more I became interested in it. When I touched on human emotion and how I could put myself into a situation, it just fascinated me. There has been nothing in my life so far that has even come close.

On my first day of class at the American Academy of Dramatic Arts in New York City, my teacher asked the class if there was anyone there to study acting because they wanted to be famous and about ten people raised their hands. Then he asked if anyone wanted to study acting to become rich and about eight people raised their hands. Finally, he asked if there was anyone there to study acting but they didn't know why and me and another guy raised our hands. He said, "You two stay, the rest of you leave until tomorrow. You don't need to be a part of this discussion." He wasn't kidding. We became friends first in that class, because we were there for the most instinctual reasons and we spent the morning talking about acting and instinct. I told him I had started acting because I felt a spark, a niche that helped me understand human emotion more than the next guy and that I wanted to explore that.

Acting is simple, but many people do not have an understanding of what is involved spiritually, emotionally, creatively, or energy-wise. You have to put yourself in a situation, make it as real as life in that moment; either

"

basing it out of your own life experience or creating it with you imagination. Whenever I pick up a piece of paper that is a commercial copy, TV copy, film copy, or stage copy, the techniques may alter, but the essence of what the life of the emotion is, or what rationally creates it or makes anyone believe it - that never changes.

I'm looking at projects that are going to freak me out and really, really attract me on an instinctual level when I lay eyes on them. THE BEAST OF WAR, a film I did last year, was just that. It excited me from the moment I read it. The film dealt with the Soviet invasion of Afghanistan, which is one of the biggest hypocrisies going on in the world right now. My character is a sensitive individual in this explosive situation - this Russian kid that was in a music class in Stalingrad one day and poof, overnight he was in Afghanistan with maybe two weeks to train. I had to live, feel and breathe in the reality of his situation and make it seem real.

I had never even had a passport before going to Israel to do that movie. Before I left, I was told I was going to receive military training and at the time, it sounded really cool. Then I got there and I was in the middle of training and I remember thinking, "What am I doing here?" I was scared, frightened and all of a sudden I felt an intense affinity for my character.

I remember sitting on the top of the tanks we were training with at 2:00 am and looking at the stars. There are a million stars over Israel. I sat there listening to Mozart on my Walkman, trying to get the whole spiritual vibe from that land and at the moment, on a moralistic and spiritual level, it made me want to pursue acting even more. I realized, that unless I'm reincarnated as a Soviet boy, I'm never going to live something like this. It was really a trip. There are only a few people in my life that really have a grip on what I'm trying to accomplish as an actor and know my level of intensity - and that's because I let them in. Acting is a never-ending struggle for me because of my outrageous pursuit of perfection, it's almost on a psychotic level.

It's an energy I feel. When I want a part really badly, I freak out sometimes. When I go into an audition, I can't be so into the script that the director thinks I'm a fucking weirdo, so I try to control that. The fire in my eyes, so to speak, will get the point across to him.

That happened when I got OUT IN AMERICA, this play I did off Broadway with Daryl Hannah. I got the part on a basic standard audition that was on the New York City breakdowns. I knew I had to play this character - he's the most passionate human being I've ever come across in a script. He was a pseudo-bisexual. His sister had committed suicide a year earlier, and a friend of his who happened to be a guy approached him, in an affectionate way.

I didn't have a grip on the sexuality as far as the homosexuality went, until Daryl and I were blocking the big kissing

scene and she tells my character he's sexy, "sexy like a girl and soft and scared like a little boy". By frustrating me and making me angry, she touched on some personal things that unraveled the connection between my sister's death and my sexuality. Not only do I fall in love with her, but I fully understand why I have fallen in love with her, and how being so vulnerable at a certain moment made me also fall in love with my friend that was a guy. That is what acting is to me; man, it's called life.

A gentleman came up to me after the play one night and said, "You know, I watched your work and the writing was not that good, but I saw everything you were trying to do. You've got this intensity that is far greater than anything I've ever seen and I understood your position in the story and I wanted to thank you for that." That was worth more money than anyone could offer me, man, because that's totally what I want to do. He was living it with me, and that's all I want.

There are a lot of politics involved in this business and a lot of schmoozing that people do in order to get somewhere. I personally would rather just bury my head in the ground. What I've done is surround myself with a manager, Pat Reeves and an agent, Michael Kingman, who support me, fight to get me auditions and keep me in line when I'm too crazy; I'm lucky to have this support in my life. My goal as an actor is to follow my instincts, to tune into that fire that is raging inside of me. I pursue it in hope that my honesty and conviction will get my point across to my audience. ★ STEPHEN BALDWIN, 1997

> There are a lot of politics involved in this business and a lot of schmoozing that people do in order to get somewhere.

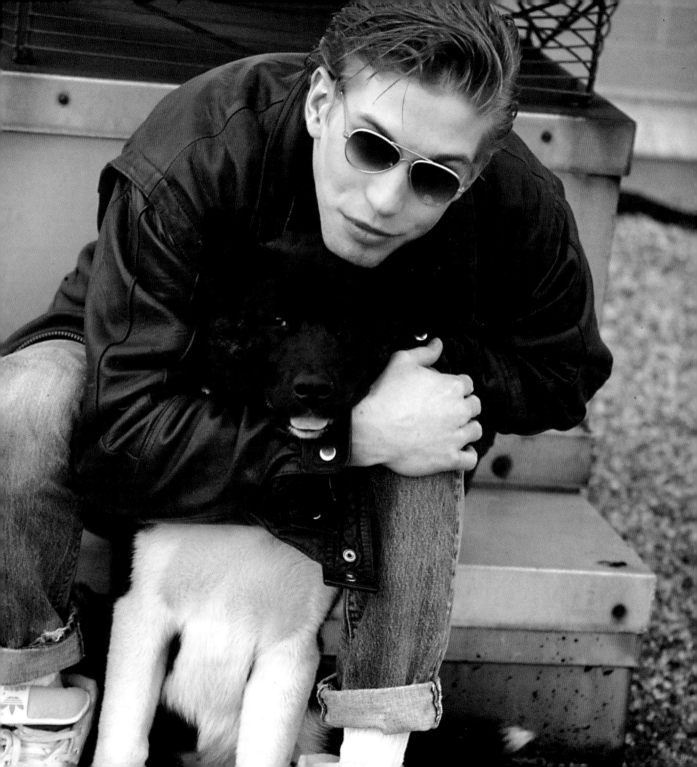

WILLEM DAFOE

In September of 1987, I met Willem Dafoe at my friend Hannes Schick's photo studio at the corner of Bowery and Second Avenue in New York City. Jack, Willem's son, accompanied him and anxiously watched as I photographed his father on the street. Nearby, a line of homeless people waited for a free meal from a shelter.

The angles in Willem's face make him a photographer's dream. I loved his performance in TO LIVE AND DIE IN LA and thought he stood out in the brilliantly cast movie PLATOON. When I met Willem, he was involved in Wooster Group, an avant-garde, experimental theater located in Manhattan's Soho District.

Willem is a true artist whose integrity as an actor has allowed him to create a space all his own. Having enjoyed a rich and diverse career, Willem became widely known to audiences worldwide after starring as the Green Goblin the box office behemoth SPIDER-MAN that had the largest opening weekend at the box office in movie history.

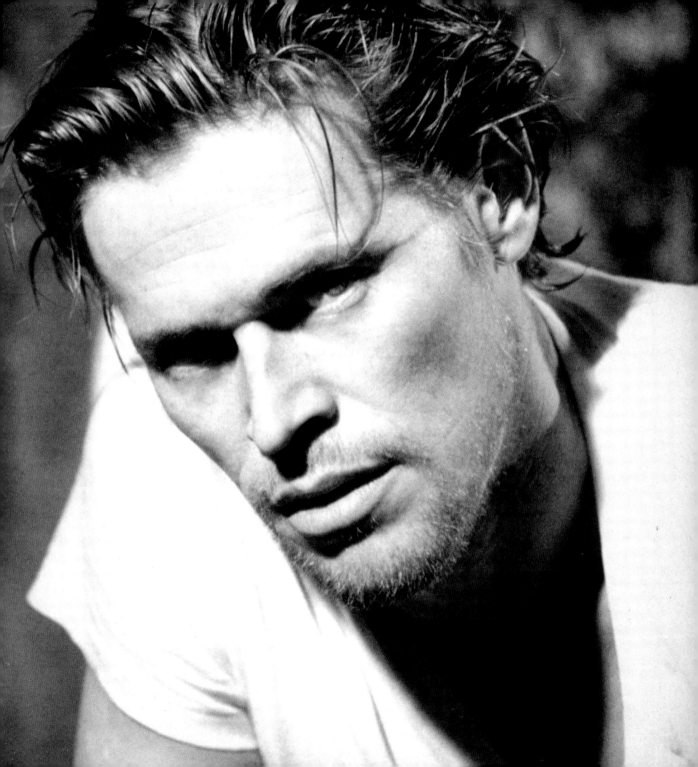

I grew up in Wisconsin. Our house seemed very big to me as a child. It was a classic white brick house. Our property bordered on farmland. I could, literally, walk outside my front door and be in the middle of a field. My father was a surgeon. We lived in a distinctly middle class area on the outskirts of town, which was just starting to get built up. My mother would describe me as a sweet kid. I decided to be an actor when I was very young. It was something I enjoyed doing. When you grow up in a large family · I was one of eight kids · you've got to find your identity and turf in that family. I was the cutup. I would get attention by doing gags and fooling around. That kind of nature led me to writing plays as a child. I used to write plays that were historical dramas and incorporate a lot of action into them. I remember my first play. It was called THE ALASKAN GOLD RUSH.

> # I used to write plays that were historical dramas and incorporate a lot of action into them.

I started making my living through acting when I was 18 with a group called Theater X. They were based in Milwaukee, Wisconsin, but, for the three years I was with them, we were very seldom there. We hooked up with a good producer in Europe and performed a lot there. It was a great experience being with a company that creates and develops its own work, but it was hard work, and I made just enough to live on. After a while, I got frustrated and, since I've always been ambitious, I moved to New York with the intention to become a commercial theater actor.

I looked around and, between what was available to me and what interested me, I could find nothing. So I started going Downtown to see performances. I went to a performance called RUMSTICK ROAD by the Wooster Group. I didn't understand it, and the performers were really good, and the place felt very important. I started hanging out with them, and, eventually, I became a regular member. I like plays and realism as much as the next guy, but to me what we do is a little more interesting because it's not an imitation of something from thin air or stuff around you. How do I prepare for a role? I like it when your personal history runs parallel to your fictional history and they sort of criss-cross each other, and inform each other. Then it all feels like the same thing, and its very exciting. That's why, when I'm making a film, I respond to exotic locations, and toys, and interesting people. Professions are fun. When I did TO LIVE AND DIE IN LA, it was fun to learn counterfeit money. There's nothing esoteric about it. If I know

I'm interested in my life and I'm crazy enough to want other people to watch me. I like being watched.

how to counterfeit money, I am a counterfeiter. If you are working with weapons and you know how to use them, it's in your body. I don't believe I, Willem, can be anyone other than I am, but through my body and in my mind there are infinite possibilities, so its all about applying my whole history, whoever I am, to a series of actions, and out of those actions comes this character. I like big, classic, genre pieces: cops, robbers, heroes, good boys, bad boys and lovers · stuff that's fun to do, characters that have substance and that I'm curious about.

What have I sacrificed for success? I try not to think in those terms. I don't think I've sacrificed anything and I'm not sure I'm a success. Once you get elevated to a certain level, people start watching you. I'm interested in my life and I'm crazy enough to want other people to watch me. I like being watched. I like company. I don't have a lot of friends, and I don't go out a lot, but somewhere deeply I am social and I like people to be with me.

The biggest misconception about me is that I'm big. People think I'm really big when they see me in the movies, but I'm only 5'9" and I weigh 145 pounds. That's actually quite slight for a man.

Which of my peers do I respect? Put it this way, I've got no shrine in my bathroom for anyone and when I go out to a place and there are celebrity types, I don't think about meeting anyone in particular.

When I was young I wanted to be a great actor. Did I want to be a movie star? I think, romantically, I wanted to be a great actor, and I still do. Now that I'm a little older, it's gotten more sophisticated. I want a good life. I want an exciting life, and I want to be able to do great roles.

It's very difficult for me to look at scripts. I'm better at telling what is bad than what is good. A lot of scripts are totally effect oriented. The tradition, particularly with a commercial movie, is to get way ahead of themselves. They want to see the movie before they get there. They end up too vague and lacking heart. For me to invest my time, I look for clarity and heart.

So why am I an actor? For my own pleasure and to create beauty. I hope people enjoy what I create.

★ WILLEM DAFOE, SEPTEMBER 1987

PATRICK SWAYZE

Patrick Swayze's journey to Hollywood stardom was long and arduous. As a child in Houston, Texas, he performed musical theater before moving to Manhattan to dance with the Eliot Feld Ballet Company. Massive knee injuries ended his ballet career and led him to musical comedy on Broadway. Eventually, he moved to Los Angeles to pursue a film career.

In Los Angeles, Patrick landed roles in a string of classic films that were critically acclaimed, including THE OUTSIDERS and RED DAWN. Finally, the summer sleeper DIRTY DANCING catapulted Patrick into the spotlight, and established him as a romantic, leading man. Suspicious of his newfound celebrity status, Patrick pushed himself creatively and continued to search for the greater truths in both his roles and his life. Over the years, he remained a solid box office draw, including the 1990 blockbuster GHOST. Patrick was recently diagnosed with pancreatic cancer and is currently undergoing treatment to battle the disease.

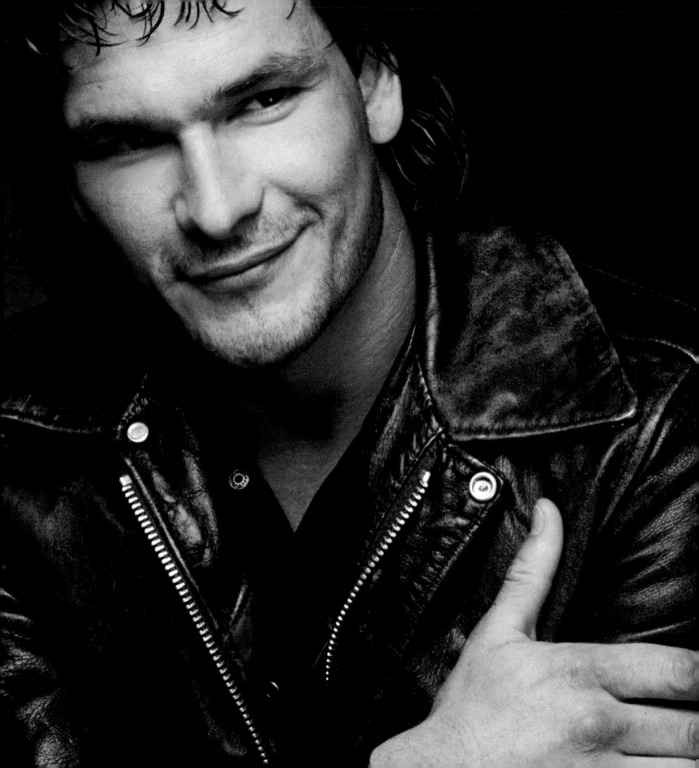

My mother didn't believe you could truly be an artist unless you were truly well rounded in every area of the arts. So I was taking dance classes, playing the violin and doing children's theater for as long as I can remember. Sometimes, other kids would make fun of me for being involved with the arts.

When I first got into Junior High School there was one really bad time when I got beaten up really badly by five guys behind the church. When I had recovered from my injuries my father came with me on my first day back at school and set it up with the head coach so that I could fight these guys, one at a time with gloves on. One of them was the school bully. He had failed three or four times - he was 18 in ninth grade. We were assembled in the weight room and the coach handed gloves to me and the other guy. My father took both pairs of gloves and tossed them. The coach said, "You can't do that," but my father said, "Watch me. My son is at least going to have the chance one-on-one to do to them what they did to him." It was a real Texas sort of way of dealing with people. I fought all five of them, one at a time and I beat them all. I thought that would fix things for me, because I had beaten the toughest guy in school, but all it did was make me the tough guy and everyone wanted to fight me after that. That made my life a little more miserable.

I got a chance to learn some big lessons early on though. At 13, I decided to quit dancing so people would leave me alone. It didn't work. It didn't change a thing. Then I realized something very important; screw the world and anyone who tries to make me believe something different than what I believe, or tell me my dreams can't come true. I never let anyone stop me, ever again, from achieving what I want to achieve.

Because I had discipline drilled into me from the time I can remember, the transition from dancing with a ballet company to doing theater was fairly painless. I understood what it took to be good on the level it required and I was willing to do that. If anything, it's become something I live my life by.

> Then I realized something very important; screw the world and anyone who tries to make me believe something different than what I believe, or tell me my dreams can't come true.

Discipline is still very important to me. Early on in Hollywood, I'd walk into offices and there were 30 other clones sitting there. I knew I was going to blow them away. I had that confidence because I had done the work and I knew I'd done the work. I never stopped studying. I never stopped continuing to grow. That was the one thing that always pulled me through. I just found that looking into most of these guys' eyes, that's as deep as you could see. They were just interested in getting out there and seeing how far they could get by on their looks and personality.

The hardest thing about acting, for me, is character studies. I find that they are the scariest things I have ever attempted. Because my function, my responsibility as an actor is to break down my barriers, my defenses, and the things I put up to insulate myself from the pain of the world. Yet somehow I still have to protect myself. It's very contradictory. I find the longer I go the deeper I go inside myself. These dark recesses and corners. Pandora's Box. You open it and you start looking into it and its very, very scary. What you ultimately end up doing is psychoanalyzing yourself, which can be dangerous if not handled correctly.

I still have a lot of life ahead of me to see if I'm successful in it. It remains to be seen. At this moment in life, I feel like I'm walking a dangerous line. That place where there's a great deal of fear coming up when I want to do a character. I'm attracted to very intense characters, so that hypes the potential power of a performance and the potential emotional damage.

I'm just trying to sort out what all of this success means; Trying to stay clear with my ideals and my integrity and not get sucked into what happens to so many people who become subject to this imitation of life in Hollywood. It's not an easy thing, because the machine is set up to suck you in. If you don't get sucked in, that's death as an actor. Right now, I'm trying to remember exactly why I'm doing this. I feel you have to have a purpose in your life. You have to have something bigger than yourself in order to keep your head on your shoulders. I've lived my life, up to this point, with a desire to make contribution through my work, and to affect people's lives in a positive way through my work and through doing press. That's why I take press very seriously. I feel I have a responsibility to do that. To return something; not to be a bloodsucker. It's also self-preservation because it keeps you out of your ego and it keeps your feet on the ground.

I'm continuing to study, but I haven't gone back to class. I've literally been doing movie after movie for eight years now. What happened, as a result of that, is I lost that purpose in my life. I've lost the passion. I wind up having to talk about that passion and my ideals and my beliefs to journalists, nonstop, until it almost sounds like bullshit instead of something I truly believe. I'm trying to rediscover that purpose and get the passion back.

Sometimes, I feel like I've given away everything and haven't kept anything for myself. I'm just fighting emptiness. Fighting this pit in my insides that I can't get rid of. It's been coming on for a few years now. I'm so accustomed to putting on the armor in the battle act, picking up my battle axes, going into the fray and trying to do quality work. I don't even know how to recognize or deal with a supportive situation anymore. It's hard when everyone around you is trying to sell you out.

The quality of scripts that are being submitted has changed drastically. Or should I say the quantity? You work so hard to get to this place in your life and then you get there and you realize it doesn't really change anything. You're offered a lot more scripts and you get a chance at the "A" projects, but you realize there are so few good scripts out there it makes you sick. So what I'm doing now is creating my own projects. I want power and passion in a script. Can

> When I take a part, I definitely consider the effect it will have on people.

I affect people's lives, or make their lives lighter for a moment, or make them understand something better through what I do?

When I take a part, I definitely consider the effect it will have on people. Everybody saw RED DAWN as a film about right-wing fascism. I saw something completely different in the role of Jed. I saw an opportunity to make an incredible anti-war statement by having people see the destruction of your soul by warlike attitudes. Adults and critics didn't get that, but the film has a cult following all over the world. The kids got it. The youth got it, and that makes me feel wonderful.

I think something has happened to the world, or at least to the United States. Apathy. People are feeling ineffectual and powerless. I want to try, in whatever way I can, to help restore that power in people. I don't have the answers to the world. I only know what I need to fix and work on myself. I find the problems I'm having, seem to be the problems that the world is having.

I try to make a difference through the things I talk about in the press and the roles I choose. DIRTY DANCING was a sweet little film, but I had a very specific point I wanted to bring out about class structure and social prejudice. I also wanted to bring dancing back to a form of communication and connection with another human being. Not just swing your butt on a dance floor in a bar so maybe you'll get picked up. My focus is to get myself back to a true

level of communication with other people, and to try and help myself, and other men try to find out what being a man means these days. I think my father's generation was doomed. Their upbringing was such that men were to act one way and women were to act another way. Now, men are required to be real, feeling, vulnerable human beings. I think we have a chance to fight our prior training so our children will have more of a chance. I've done some badass characters, but what I try to do is bring them to a level of vulnerability and sensitivity, to create something that is sought after rather than feared.

To prepare for a role, I do as much literal and physical research as necessary, but my biggest focus is where my character comes from and what his history is. I write a whole scenario about his life · what kind of parents he had, what kind of car he drives. The kind of problems he has, and how they manifest themselves physically through quirks. Your character is revealed through how you conceal emotion. Your whole key as an actor, is the ability to conceal emotion. Letting the audience get to know your character by what he is trying to cover up, what he really wants.

My biggest sacrifice for success is that I find I have to be more reserved and more reclusive. The loneliness is intense, even in my personal relationships. I'm being hit from all sides and then some and I've got to protect myself. The world wants you to see this and that. I read this Newsweek article about me that blew me away. It's about a cult that's developing around Johnny Castle from DIRTY DANCING. These women are starting a club for women who love Patrick Swayze too much. It's very weird.

It's not easy to believe the hype when everyone is expecting you to believe it. "Well, how does it feel to be a sex symbol?" "How does it feel for women to be screaming and going crazy for you?" I have

It made me feel like there was a purpose to this lunacy.

to put it in some sort of real perspective. In Germany and Norway I had ten bodyguards non-stop. It's weird to be standing insulated by these bodies and all these people are trying to get at you, screaming and crying. I realized something at that moment; I'm only a catalyst, as is any rock star or movie star or anyone who is publicly idolized. You are only a catalyst for people to release something because, God, I saw panic and need in these eyes to get something out. I'm realizing now they're not screaming for me. I'm just affording them the opportunity. That made me feel proud, in that moment. It made me feel like there was a purpose to this lunacy.

Being an actor can be a struggle for me, but, as much as I talk about the fear and needing to sort it all out, right

now is the most exciting challenge I've ever had in my life. As an actor, a dancer and a songwriter, my creative possibilities are infinite. There's so much room to grow.

If I could star in a biopic, I'd like to play Jim Morrison. I know Travolta has always wanted to do it. He's pushed and pushed and pushed to try and get that role, but there are too many legal problems right now. I'd like to do it for many reasons. I don't believe Morrison was a God, like many people think. I believe he copped out and ran away. I'd like to play him from a realistic point of view. This man who was driven crazy by his own soul. If I could play Jim Morrison, I think I'd blow people away. I'm trying to sort that out for myself, in life and I'd love to do that sort of character on screen.

Spiritually, it's important to me to continue to find my center. In martial arts you call it finding your Ki. I live my life for those moments as an actor, a dancer and a singer, because it's in those moments that you have an innate, organic understanding of how you fit into this world. I found martial arts to be a wonderful release, a connection. When you truly find your Ki it's amazing.

It's really interesting where things are going in this world. Alarms are going off in my insides, big time, because I think things are really, really dangerous now. It all has to do with a lethargic attitude about life. People are screaming. Screaming to find a group. To find a religion. To find something. To have some sort of harmony with other people. My purpose as an actor is to help with that harmony. ★ PATRICK SWAYZE, DECEMBER 1987

If I could play Jim Morrison, I think I'd blow people away.